AFRICA
IN THE WORLD
PAST AND PRESENT

A MUSEUM HISTORY

BEN BURT

THE BRITISH MUSEUM PRESS

Published in 2005 by the British Museum Press
A division of the British Museum Company Ltd
38 Russell Square, London WC1B 3QQ

ISBN 07141 2571-7

ISBN 9780714125718

Ben Burt has asserted his right to be identified as the author of this work.

A catalogue record for this title is available from the British Library.

Designed by seagulls
Maps designed by ML Design
Printed and bound in China by C&C Offset Printing Co., Ltd.

STAFFORDSHIRE LIBRARY AND INFORMATION SERVICES
Please return or renew by last date shown

If not required by other readers this item may be renewed, in person, by post or by telephone. Please quote details above and due date for return. If issued by computer, the numbers on the barcode label on your ticket and on each item, together with date of return are required.

24HOUR RENEWAL LINE - 0845 33 00 740

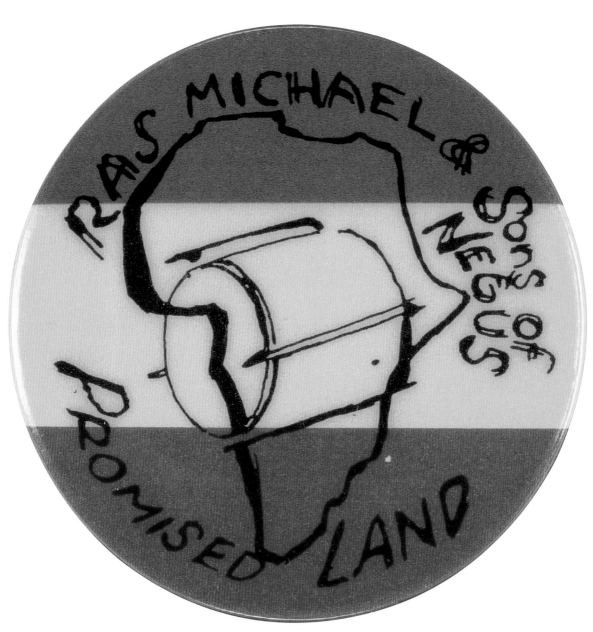

The idea of Africa is easily evoked by the outline of the continent, as in this badge for the Jamaican band Ras Michael and Sons of Negus, purchased at the Notting Hill Carnival in London in 1983. But like the band, whose Rastafarian religion and nyabinghi music are African-inspired, Africa has never been confined to this map, as this 'museum history' will show.

AFRICA IN THE WORLD

Museum collections have many stories to tell, depending on how the objects are chosen, displayed and explained. This book uses the collections of the British Museum to illustrate a history of Africa's place in the wider world. At the time of writing, most of the objects featured are exhibited in the British Museum's galleries, but usually to tell quite different stories of other places and peoples. A few come from other museums which tell stories the British Museum does not. Here they are all used first of all to explain the many centuries of relationships between Africans and the other peoples of the world.

What do we mean by Africa?

Since ancient times, the continent of Africa has been home to people of many different origins and cultures. Some trace their origins within Africa, but others have ancestors from Europe and Asia, from as far apart as Britain and China. And people of African origins have long lived in other parts of the world; for 500 years in the Americas and much longer in western Europe, south-west Asia and India. Which of the world's diverse peoples are identified as African, by themselves or by others, depends as much on the complex historical relationships between them as on the geography of the continent.

. . . and does it matter?

People use history and culture not only to understand their world, but also to maintain it or change it, and the way they identify themselves and others is an important part of this. In this book we are less interested in defining 'Africa' than in looking at the histories of people's relationships to the continent, which have contributed to a variety of African identities.

1

AFRICA'S FIRST KINGDOMS

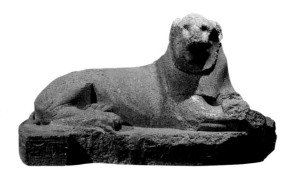

How did African civilisation arise?

By 12,000 BC, when humans throughout the world lived by foraging for wild foods, Africans were forming settled communities in well-watered, fertile parts of the Sahara and along the Nile. As the changing climate began to dry the region out, more people were forced into the Nile valley, kept fertile by its annual floods, where they increasingly planted and bred the wild crops they depended on. By 4,000 BC similar developments in Mesopotamia led to the introduction of new crops, livestock and technologies.

In Egypt, as in other regions where foragers turned to farming, increased food production led to increased populations, with leaders organising their growing communities to work, distribute surplus food and defend lives and goods against hostile neighbours. By promoting specialisation in government, manufacturing, religion and war, community leaders became rulers, supported by the production of peasant farmers. They claimed to represent gods who ordained the hierarchy of human society and ensured the continuation of the natural order, especially the fertility of the land.

While Egypt flourished, the Sahara turned to grassland and eventually to desert, and its farmers and herders retreated to more habitable lands north and south. By about 2000 BC there was a broad band of desert across the continent, with the Nile as the most inhabited route across it.

Power in this world . . .

The rulers of Egypt proclaimed their greatness to present and future generations with magnificent monuments. Their achievement was to develop a political and administrative system drawing wealth from the produce and labour of peasant farmers for grand public works. This monumental granite lion, one of a pair, was made in Egypt in about 1400 BC for a temple in Upper Nubia, then under Egyptian control. More than 1000 years later it was removed by a king of Meroe to a temple nearer his capital.

. . . and in the next

In death the grandeur of kings, administrators and priests was proclaimed by lavish tombs. These ensured their status in the afterlife, provided they could negotiate their way through the administrative system of the gods. This 13th-century BC papyrus shows the gods weighing a dead man's heart against the feather of truth, while the monstrous 'devourer' awaits if he fails the test.

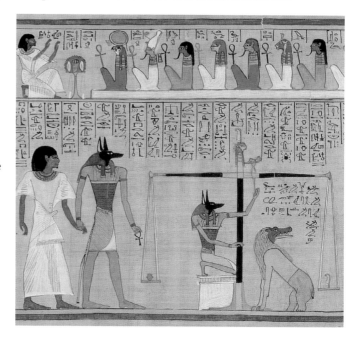

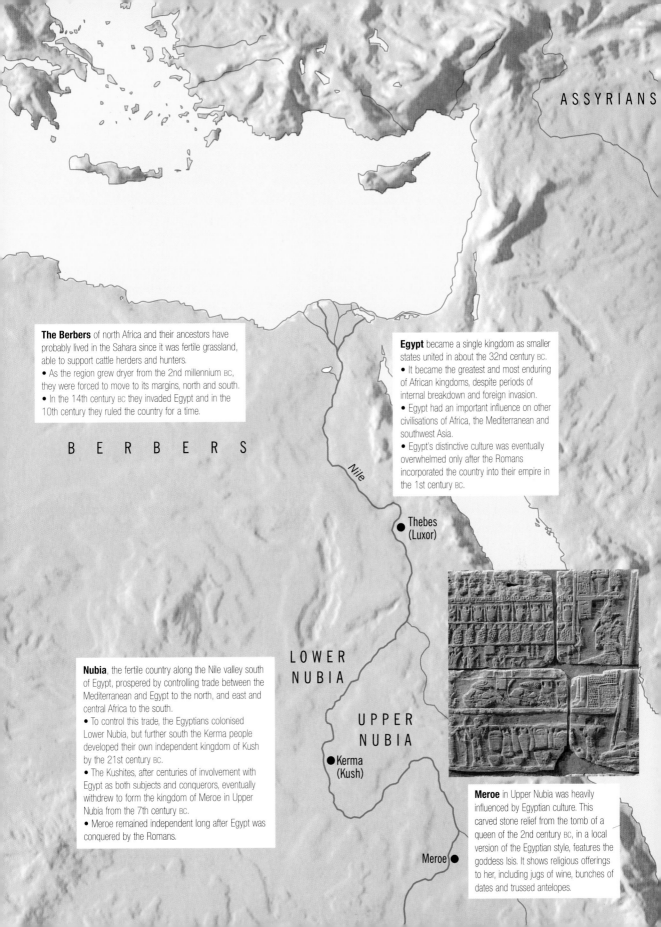

ASSYRIANS

The Berbers of north Africa and their ancestors have probably lived in the Sahara since it was fertile grassland, able to support cattle herders and hunters.
• As the region grew dryer from the 2nd millennium BC, they were forced to move to its margins, north and south.
• In the 14th century BC they invaded Egypt and in the 10th century they ruled the country for a time.

B E R B E R S

Egypt became a single kingdom as smaller states united in about the 32nd century BC.
• It became the greatest and most enduring of African kingdoms, despite periods of internal breakdown and foreign invasion.
• Egypt had an important influence on other civilisations of Africa, the Mediterranean and southwest Asia.
• Egypt's distinctive culture was eventually overwhelmed only after the Romans incorporated the country into their empire in the 1st century BC.

Nile

● Thebes
(Luxor)

L O W E R
N U B I A

U P P E R
N U B I A

Nubia, the fertile country along the Nile valley south of Egypt, prospered by controlling trade between the Mediterranean and Egypt to the north, and east and central Africa to the south.
• To control this trade, the Egyptians colonised Lower Nubia, but further south the Kerma people developed their own independent kingdom of Kush by the 21st century BC.
• The Kushites, after centuries of involvement with Egypt as both subjects and conquerors, eventually withdrew to form the kingdom of Meroe in Upper Nubia from the 7th century BC.
• Meroe remained independent long after Egypt was conquered by the Romans.

●Kerma
(Kush)

Meroe ●

Meroe in Upper Nubia was heavily influenced by Egyptian culture. This carved stone relief from the tomb of a queen of the 2nd century BC, in a local version of the Egyptian style, features the goddess Isis. It shows religious offerings to her, including jugs of wine, bunches of dates and trussed antelopes.

SETTLED LIFE AND CIVILISATION: THE FIRST FIVE THOUSAND YEARS

	SAHARA	EGYPT	LOWER NUBIA	UPPER NUBIA
5000	**Since 11th millenium** Some communities already settled and making pottery			
4500		**5th–4th millennium** Egyptians develop farming with new crops from southwest Asia		
4000	**4th millennium** Cattle-herding		**4th millennium** Farming and cattle-herding begins	**4th millennium** Farming and cattle-herding begins
3500			**35th–30th century** Farming and herding spreads. Trade develops, supplying raw materials from further south to Egypt in return for manufactures	
3000		**Mid-31st century** States of Upper and Lower Egypt joined in one kingdom		
2500	**3rd–2nd millennium** Sudanic peoples begin farming local grains such as millet	**Early 26th century** Old Kingdom begins; wealth and power grows with expansion of trade and conquest to the south. The pyramids are built	**25th century** Egyptians begin colonising to exploit copper and other resources **22nd century** Newcomers form stable settlements with strong chiefs controlling luxury goods trade from the south to Egypt	
2000		**Late 22nd–21st century** Period of disorder **Mid-20th century** Middle Kingdom begins, capital at Thebes, kingdom expands to Nubia **Early 18th century** Kingdom collapses with invasion of Asian nomads	**21st century** Trade with Egypt disrupted by political breakdown there **20th century** Conquest by Egyptians, who build forts to secure trade	**21st century** Kingdom of Kush develops with its capital at Kerma, controlling trade between central and east Africa and Egypt
1500	**2nd millennium** The Sahara gradually turns to desert **14th century** Lybian Berber herders invade Egypt	**Mid-16th century** New Kingdom begins as Egyptians regain control, expand into Nubia and southwest; a period of great wealth and power **14th century** Berber invasions **c.1325** Tutankhamen	**c.1270** Ramesses II builds Abu Simbel **13th century onwards** Population decline, perhaps caused by Egyptian over-exploitation	**Late 17th century** Kush reaches the height of its wealth and power and conquers Egyptian territories of lower Nubia **15th century** Egyptians conquer Kush and exact tribute
1000	**10th century** Trade develops across Sahara. Berbers set up a kingdom in Egypt	**Early 11th century** Breakdown of government **Mid-10th century** Berbers invade and rule part of Egypt **Mid-8th century** Kushites of Nubia conquer and rule all Egypt		**8th century** Egyptians lose control and a new Kushite kingdom arises, conquers the whole of Egypt and rules it for 50 years
500		**Mid-7th century** Assyrians conquer Egypt and expel Kushite rulers (see Bible, 2nd Book of Kings), then Egyptians regain control **Late 4th century** Greeks under Alexander conquer and rule Egypt as the Ptolomy dynasty		**Mid-7th century** Kushites driven from Egypt and rebuild their own kingdom with its capital at Meroe **3rd century** Meroe reaches the height of its power and builds independent culture
0	**1st century** Romans conquer northern Africa	**1st century** Cleopatra, the last Pharaoh **Late 1st century** Romans conquer Egypt and integrate it into their empire	**Late 1st century** conquered by the Romans	**Late 1st century** Meroe attacks Roman Nubia but is defeated

Paying tribute to Egypt

This reproduction of an Egyptian mural from Lower Nubia from the 13th century BC (the New Kingdom) shows an Egyptian viceroy of Nubia presenting the annual tribute to king Ramesses II. The goods include slaves, bags and rings of gold, leopard skins, elephant tusks, ebony logs, ostrich eggs and feathers, manufactured goods such as bows, shields and fans and various live animals.

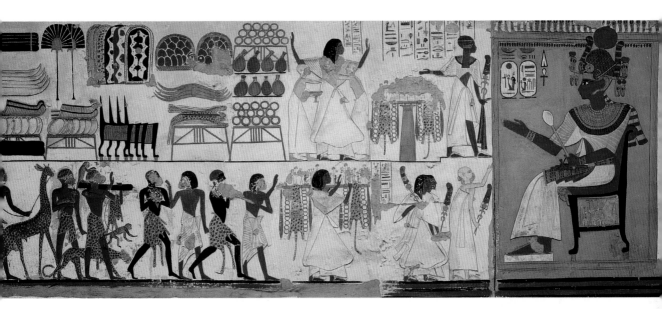

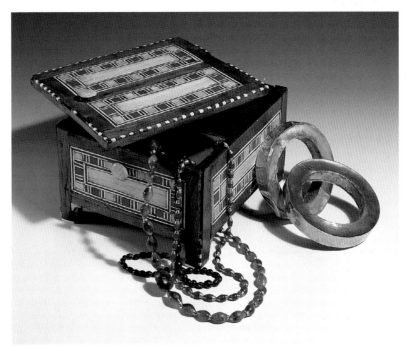

The wealth of Nubia

Some Egyptian imports from Nubia: gold bangles, a cosmetic box of ebony inlaid with ivory and jewellery of semi-precious stones.

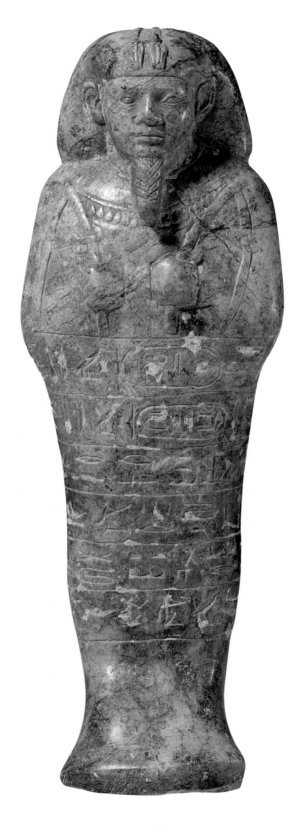

Egyptian Nubia

When the New Kingdom Egyptians conquered Nubia they followed a policy of Egyptianisation, educating the local rulers through whom they governed. When the Nubian Kushites conquered and ruled Egypt in their turn, their kings became more Egyptian than the Egyptians. They continued to be so after they were expelled and retreated to Kush in the mid-7th century, as we can see from this figure from the pyramid tomb of a king at Nuri in Upper Nubia. It is one of the shabti images of the dead man, made to perform his duties in the afterlife, and it clearly shows him as a Black African. It is inscribed with prayers revived from the Egyptian culture of centuries earlier.

What was Egypt's role in Africa?

As Africans, the ancient Egyptians had much in common with other peoples of the continent, and as a powerful civilisation they have had a major influence on their neighbours, in Africa and beyond, from ancient times to the present. Since Europe rediscovered Egyptian history in the 19th century, many scholars have traced cultural developments around the world, from pyramid building in the Americas to mummification in Papua New Guinea, to 'diffusion' from ancient Egypt. More recently, some African historians have claimed ancient Egyptian origins for African cultural practices thousands of years later.

Such 'diffusionist' theories often rely on perceived similarities between peoples widely separated in time and space, rather than on evidence of historical relationships between them. The danger is that they underestimate the ability of the world's peoples to develop culture for themselves, both by local innovation and by adapting ideas from many different sources. Egyptians were not the only Africans capable of building complex civilisations, and the history of Africa is bound up with the rest of the world in many ways. For example, some regard Egypt as the origin of the African custom of kings claiming to be divine, making them responsible for the fertility and prosperity of their domain and setting them apart from ordinary people. But this could also be a feature of African culture in general. Bearing in mind that divine kings have ruled all over the world, from Europe to China, the Americas to Polynesia, there are likely to be other explanations.

Were the Ancient Egyptians 'Black'?

It depends what you mean by 'Black'. Despite the strict stylistic rules of their painting and sculpture, the ancient Egyptians were careful to distinguish different peoples by their physical appearance. They show themselves as reddish-brown with features much like Egyptians today and the Nubians and peoples to the south as darker brown or black, with features like Black Africans. These differences are confirmed by archaeological human remains. But during their long history there was regular trade and frequent invasion between lands north and south, resulting in much intermarriage. In certain periods the Nubians became culturally Egyptian and at one stage they ruled the whole of Egypt as a dynasty which behaved in a manner more Egyptian than the Egyptians. These pharaohs and their followers were distinctly Black in physical appearance.

2

AFRICA AND THE ANCIENT MEDITERRANEAN

What part did Africa play in Mediterranean civilisation?

The Mediterranean has linked the peoples of Africa, Europe and southwest Asia through trade, migration, colonisation and conquest since ancient times. Phoenicians, Greeks and Romans enriched themselves in trade with Africa, learnt much from the more ancient and sophisticated civilisation of Egypt, settled along the African coasts, fought for territory and introduced their own ways of life. Goods, people and ideas travelled between the Mediterranean and African lands far away across the Sahara and up the Nile.

African influence on Greece

The cultural influences which contributed so much to the development of Greek civilisation are illustrated in these two statues. The Egyptian one, of about 2200 BC, stands in a typical stylised pose, left leg forward and arms by his sides . . . and so does the Greek one from about 560 BC (as can be seen from the broken stone where his forearms were once joined to his hips).

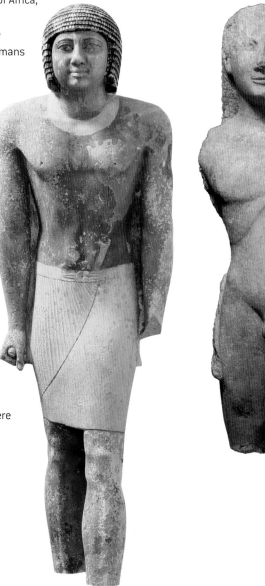

BC	MEDITERRANEAN	NORTHERN AFRICA	SOUTH OF THE SAHARA
1000		**Mid-10th century** Berbers invade and rule part of Egypt	**10th century** Trade develops via ancient routes across the Sahara
900	**9th century** Phoenicians trade along coast of north Africa to Spain and Britain via colonies such as Carthage		
800			
700	**7th century** Greeks establish colonies in north Africa (Cyrenicia)		
600		**6th century** Egypt conquered by the Persians	**Mid-1st millenium** Iron smelting begins in west Africa (Nok) and around Lake Victoria
500	**5th century** Carthage becomes an independent trading empire		
400			
300	**Late 4th century** Alexander conquers Greece, Egypt and southwest Asia	**Late 4th century** Egypt conquered by Alexander	
200	**2nd century** Rome incorporates its trade competitor Carthage, Tunis and Algeria into the Roman empire	**3rd century** Meroe reaches the height of its power	
100			
0	**Late 1st century (BC)** Romans conquer Egypt	**Late 1st century (BC)** Egypt & Lower Nubia conquered by the Romans	**1st century (AD)** New Berber kingdoms in the Sudan
100		**1st century (AD)** Introduction of camels from Arabia leads to expansion of trade across Sahara	
200			**1st to 4th centuries** Bantu peoples expand into east Africa
300	**4th century** Roman capital moves to Byzantium and Christianity becomes the official religion	**4th century** Christianity reaches Ethiopia, Coptic church establishes Egyptian religious independence from Byzantium	
400			
500			

An African Roman emperor

This larger-than-life marble statue from Alexandria in Egypt portrays the Lybian Septimus Severus. He became emperor of Rome through civil war, ruled from AD 193 to 211, and died at York in England.

Africa and Italy

The fact that Black Africans were in touch with Italy even before the Roman conquests of northern Africa is illustrated by this Etruscan mug from around the beginning of the 3rd century BC.

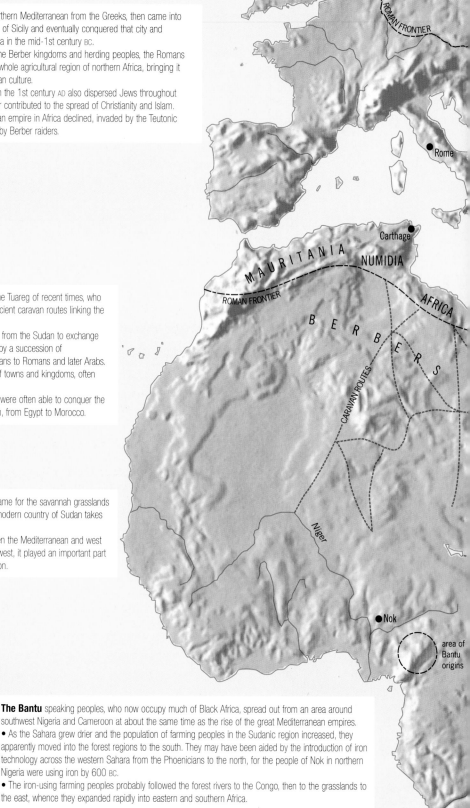

The Romans took control of the northern Mediterranean from the Greeks, then came into conflict with Carthage over the control of Sicily and eventually conquered that city and established their own province of Africa in the mid-1st century BC.

• To defend their conquests against the Berber kingdoms and herding peoples, the Romans eventually conquered and settled the whole agricultural region of northern Africa, bringing it further into the sphere of Mediterranean culture.

• The Roman conquest of Palestine in the 1st century AD also dispersed Jews throughout north Africa, where their influence later contributed to the spread of Christianity and Islam.

• During the 5th century AD the Roman empire in Africa declined, invaded by the Teutonic Vandals across Gibraltar and assailed by Berber raiders.

The Berbers included traders, like the Tuareg of recent times, who crossed the encroaching desert by ancient caravan routes linking the Mediterranean to the Sudanic region.

• They brought gold, ivory and slaves from the Sudan to exchange for the manufactured goods supplied by a succession of Mediterranean peoples, from Phoenicians to Romans and later Arabs. This trade contributed to the growth of towns and kingdoms, often under Berber control.

• Berber herders, as mobile nomads, were often able to conquer the settled farming peoples they dealt with, from Egypt to Morocco.

The Sudan or Sudanic region is a name for the savannah grasslands south of the Sahara, from which the modern country of Sudan takes its name.

• As a region controlling trade between the Mediterranean and west Africa, with transport routes east and west, it played an important part in the development of African civilisation.

The Bantu speaking peoples, who now occupy much of Black Africa, spread out from an area around southwest Nigeria and Cameroon at about the same time as the rise of the great Mediterranean empires.

• As the Sahara grew drier and the population of farming peoples in the Sudanic region increased, they apparently moved into the forest regions to the south. They may have been aided by the introduction of iron technology across the western Sahara from the Phoenicians to the north, for the people of Nok in northern Nigeria were using iron by 600 BC.

• The iron-using farming peoples probably followed the forest rivers to the Congo, then to the grasslands to the east, whence they expanded rapidly into eastern and southern Africa.

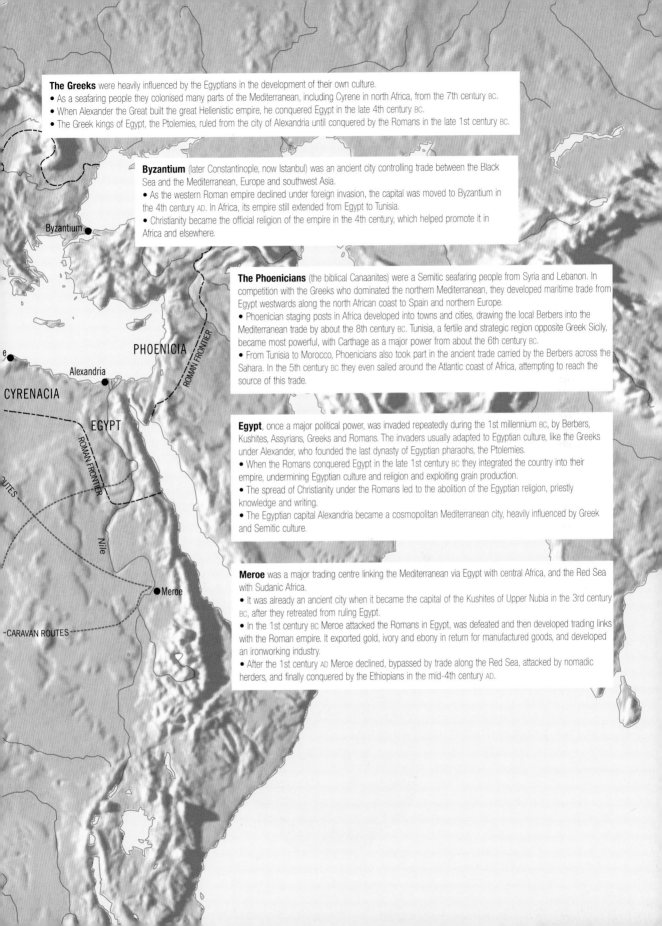

The Greeks were heavily influenced by the Egyptians in the development of their own culture.
- As a seafaring people they colonised many parts of the Mediterranean, including Cyrene in north Africa, from the 7th century BC.
- When Alexander the Great built the great Hellenistic empire, he conquered Egypt in the late 4th century BC.
- The Greek kings of Egypt, the Ptolemies, ruled from the city of Alexandria until conquered by the Romans in the late 1st century BC.

Byzantium (later Constantinople, now Istanbul) was an ancient city controlling trade between the Black Sea and the Mediterranean, Europe and southwest Asia.
- As the western Roman empire declined under foreign invasion, the capital was moved to Byzantium in the 4th century AD. In Africa, its empire still extended from Egypt to Tunisia.
- Christianity became the official religion of the empire in the 4th century, which helped promote it in Africa and elsewhere.

The Phoenicians (the biblical Canaanites) were a Semitic seafaring people from Syria and Lebanon. In competition with the Greeks who dominated the northern Mediterranean, they developed maritime trade from Egypt westwards along the north African coast to Spain and northern Europe.
- Phoenician staging posts in Africa developed into towns and cities, drawing the local Berbers into the Mediterranean trade by about the 8th century BC. Tunisia, a fertile and strategic region opposite Greek Sicily, became most powerful, with Carthage as a major power from about the 6th century BC.
- From Tunisia to Morocco, Phoenicians also took part in the ancient trade carried by the Berbers across the Sahara. In the 5th century BC they even sailed around the Atlantic coast of Africa, attempting to reach the source of this trade.

Egypt, once a major political power, was invaded repeatedly during the 1st millennium BC, by Berbers, Kushites, Assyrians, Greeks and Romans. The invaders usually adapted to Egyptian culture, like the Greeks under Alexander, who founded the last dynasty of Egyptian pharaohs, the Ptolemies.
- When the Romans conquered Egypt in the late 1st century BC they integrated the country into their empire, undermining Egyptian culture and religion and exploiting grain production.
- The spread of Christianity under the Romans led to the abolition of the Egyptian religion, priestly knowledge and writing.
- The Egyptian capital Alexandria became a cosmopolitan Mediterranean city, heavily influenced by Greek and Semitic culture.

Meroe was a major trading centre linking the Mediterranean via Egypt with central Africa, and the Red Sea with Sudanic Africa.
- It was already an ancient city when it became the capital of the Kushites of Upper Nubia in the 3rd century BC, after they retreated from ruling Egypt.
- In the 1st century BC Meroe attacked the Romans in Egypt, was defeated and then developed trading links with the Roman empire. It exported gold, ivory and ebony in return for manufactured goods, and developed an ironworking industry.
- After the 1st century AD Meroe declined, bypassed by trade along the Red Sea, attacked by nomadic herders, and finally conquered by the Ethiopians in the mid-4th century AD.

Byzantium

PHOENICIA

ROMAN FRONTIER

e

Alexandria

CYRENACIA

EGYPT

ROMAN FRONTIER

Nile

UTES

Meroe

CARAVAN ROUTES

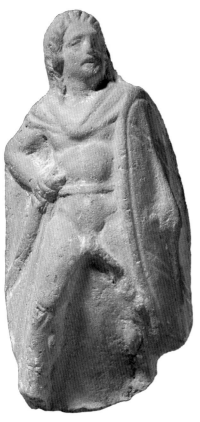

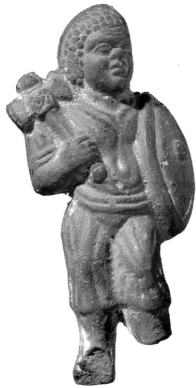

Egypt and Europe

These two small pottery figures show mercenaries from the army of the Egyptian king Ptolemy IV. Their distinctive features and weapons identify one as a Gaul from France, the other as a Nubian from the Sudan. During the 3rd century BC the Greek rulers of Egypt dominated most of the eastern Mediterranean, and Nubians and Gauls would have served together in these places.

Mediterranean pottery from Africa

This amphora is a Mediterranean style of vessel for transporting wine and oil, but it comes from Meroe where it was a luxury vessel in the 1st century BC.

From this period a major pottery industry flourished at Aswan in Nubia. It used Mediterranean wheel technology to produce wares in the styles required for the Roman market, like the 5th-century plate, with fish decoration.

More utilitarian pots continued to be made by coiling and beating; the method used throughout Black Africa.

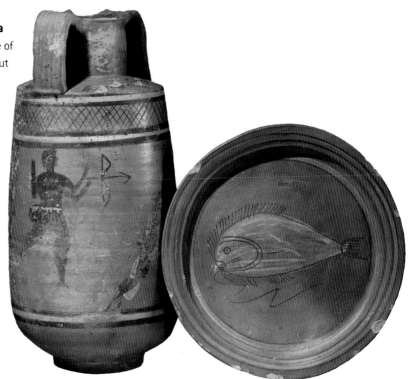

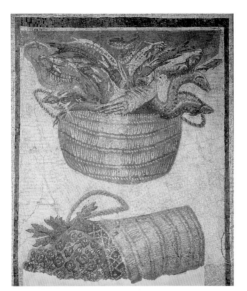

Roman Africa

This Roman-style floor mosaic is from Carthage, the African city founded by the Phoenicians and conquered by the Romans in the 1st century BC. It was made in the 1st or 2nd centuries AD and shows local fish and fruit, foods characteristic of the Mediterranean lands.

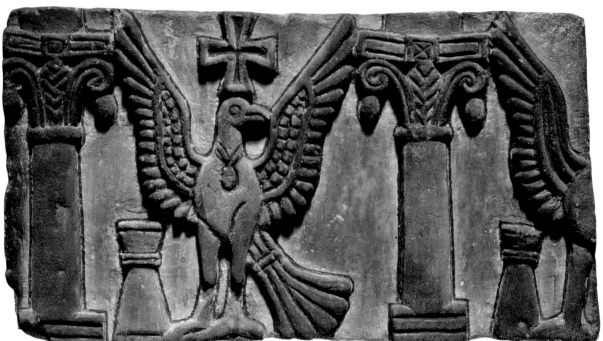

African Christianity

This piece of a stone frieze, with Christian symbols of eagles or doves and crosses, comes from an early 7th-century Coptic cathedral in lower Nubia. Christianity spread through north Africa under the Roman empire, and African Christians such as Saint Augustine (born 354 in Numidia, northeast Algeria) played an important part in the development of the religion.

The Coptic church grew up in Egypt, where Christianity became a religion of those oppressed by Roman rule. Its literature was in the Egyptian language instead of Greek and the church became independent in the 4th century, when Christianity became the official religion of the Byzantine Roman empire. In the 5th century, after the fall of Meroe, Coptic missionaries introduced Christianity to the kingdoms of Upper Nubia.

3
AFRICA AND ISLAM

Africa in the European Middle Ages

With the decline of the Roman Empire, the Arab invasions of the 7th century brought northern Africa under the new political and cultural order of Islam, with its centre further east in Iraq. In Muslim Africa the centres of power were towns linked by trade, religious institutions and the military dominion of local sultans. Herding peoples and Islamic revival movements regularly challenged the urban elites, forming new ruling groups in their turn. A network of overland trade routes, travelled by Berber camel caravans, linked Sudanic Africa to north Africa and thence to Europe and southwest Asia. As time went on, religious identity became a focus for wars of conquest between Islam and European Christendom.

The kingdoms of west Africa

From trading centres in the Sudanic region such as Gao and Timbuktu, river and pack routes led into the forests to the south. From this region came most of the gold used in Europe and Asia, slaves for southwest Asia, cloth, ivory, pepper and kola nuts (as a Muslim alternative to alcohol). In return went manufactured goods of brass, copper, glass and cloth, as well as horses and Saharan salt.

Trade and conflict with Berbers carrying the goods across the Sahara to north Africa may have led Sudanic farming communities to support strong leaders who controlled the trade and claimed to rule by divine descent. The long-distance contacts of their nomadic herding neighbours also brought new notions of leadership, deriving from peoples displaced by the Muslim invasions of north Africa from the early 7th century. As bearers of the cosmopolitan religion and culture of Islam, these peoples played leading roles in the Sudanic kingdoms as merchants, administrators and

sometimes conquering rulers. But the ordinary peasants long retained their own religious traditions, based on reverence for their ancestors and local gods.

Trade across the Sahara

This English brass jug from the late 14th century is evidence of the ancient trade across the Sahara as far south as the forest region. In the late 19th century it was still used for rituals in the palace of the king of Asante at Kumasi in modern Ghana.

	EUROPE	NORTH AFRICA	SUDANIC AFRICA	SOUTH-WEST ASIA
500				
600		**7th century** Muslim Arabs conquer from Egypt to Morocco		**622** Muhammed founds the Islamic community
700	**Mid-8th century** Berbers form the Muslim kingdom of Andalus		**8th century** Rise of Ghana empire	
800				
900				
1000		**10th century** Rise of Shiite movement and Fatimid empire		
1100	**'1066** and All That' **End of 11th century** The First Crusade	**Mid-11th century** Arab invasions	**11th century** Decline of Ghana empire	**End of 11th century** Beginning of Crusader invasions
1200		**1187** Egypt conquered by Saladin, followed by Mamluks **Early 13th century** Rise of Almoravid empire of Morocco	**Mid-12th century** Rise of Mali empire	
1300	**Late 13th century** The Last Crusade			**Late 13th century** Crusaders finally expelled
1400			**End of 14th century** Rise of Songai empire	
1500	**1492** Christians conquer Muslim Granada	**1517** Mamluk regime ended by Ottoman Turks		
1600			**Late 16th century** Fall of Songai and Mali empires	

African gold

Gold regalia like this collar worn by a 19th-century king of Asante in southern Ghana is far removed in time and space from the ancient Sudanic kingdoms. But it illustrates the wealth on which those kingdoms were founded, and its use to glorify their rulers.

The Yoruba kingdoms

This brass head of a king was dug up in 1938 at Ife, the city state from which the Yoruba of southwest Nigeria trace their origins. Such sculptures, of brass or pottery, made between the 12th and 15th centuries, were still in use in the forest shrine of the god Olokun in the early 20th century. They may have been buried and dug up again for the funerals of successive kings. European scholars once doubted that their naturalistic style was African but now recognise the local origin of these sculptures.

Europe traded with Africa throughout the Medieval period, importing ivory and gold in return for manufactured goods.
• In the west the trade was carried across the Sahara by the Berbers and in the east it went through Egypt.
• The Portuguese broke African control of this trade by sailing around the continent and reaching Asian markets by the end of the 15th century.

Spain was conquered by Africans of Berber and Arab origins during the upheavals caused by the Muslim conquests.
• In the early 8th century they established the kingdom of Andalus and built a prosperous civilisation. This was based on agricultural and industrial development at home, and trade with north Africa, across the Sahara to west Africa, and with Muslim realms to the east.
• After centuries of intermittent war inspired by militant Christianity, the kingdoms of northern Spain gained control of the whole country with the conquest of Granada at the end of the 15th century. They did their best to eradicate centuries of Muslim culture.

Ghana is the earliest west African empire for which historical records survive, from 8th-century Arab sources.
• Its wealth and power were based on trade in gold from the south for Saharan salt and north African manufactures, carried by independent Tuareg Berbers.
• The king of Ghana was treated as divine. He had a large administration, including literate Muslims, and a great army to exact tribute from neighbouring kingdoms and monopolise trade to the north and south.
• Ghana was conquered and converted to Islam in the 11th century by Berber Islamic militants. Thereafter the empire declined as other kingdoms competed for wealth and power.

Mali was an empire of the Mande people which succeeded Ghana in the mid-13th century as the major power in the Sudanic region.
• It extended a rule of peace, prosperity and law from the Atlantic coast to the Hausa states of northern Nigeria.
• During one king's pilgrimage to Mecca in the 14th century his thousands of retainers and massive expenditure of gold seriously disrupted the economy of Egypt on the way.

Songhai was a kingdom based on the trading centre of Gao, which was ruled by the Mali empire until it gained independence at the end of the 14th century.
• During the second quarter of the 15th century Songai conquered much of the Mali empire and extended further into the Sahara salt-producing region.
• Its rulers were weakened by struggles between the supporters of local Songai religion and culture and of the Islamic tradition of Mali.
• Military adventurers from Morocco brought the empire down in 1591.

The forest kingdoms of west Africa traded with the Sudanic empires but were protected by the forest from invasion by the Sudanic cavalry.
• In southwest Nigeria the Y
an important political centre from the 10th century.
• Benin in Nigeria was already a powerful kingdom by the time Europeans arrived in west Africa.

ISLAMIC EMPIRE FRONTIER

SPAIN

MAGHRIB

ISLAMIC EMPIRE FRONTIER

GHANA

SONGHAI

KA

MALI

Niger

Ife

BENIN

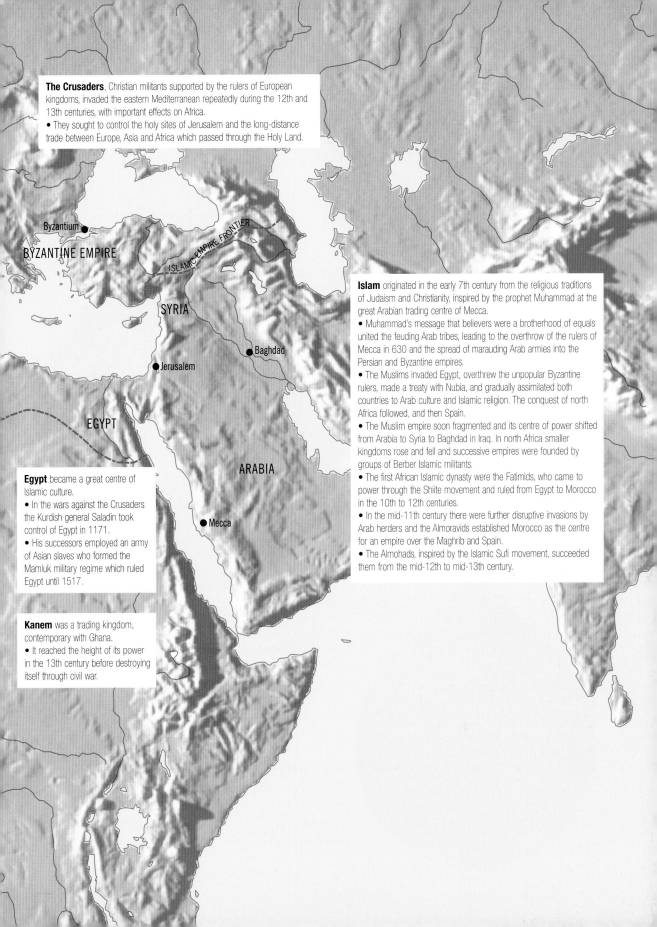

The Crusaders, Christian militants supported by the rulers of European kingdoms, invaded the eastern Mediterranean repeatedly during the 12th and 13th centuries, with important effects on Africa.
● They sought to control the holy sites of Jerusalem and the long-distance trade between Europe, Asia and Africa which passed through the Holy Land.

Byzantium

BYZANTINE EMPIRE

ISLAMIC EMPIRE FRONTIER

SYRIA

Baghdad

Jerusalem

EGYPT

ARABIA

Mecca

Islam originated in the early 7th century from the religious traditions of Judaism and Christianity, inspired by the prophet Muhammad at the great Arabian trading centre of Mecca.
● Muhammad's message that believers were a brotherhood of equals united the feuding Arab tribes, leading to the overthrow of the rulers of Mecca in 630 and the spread of marauding Arab armies into the Persian and Byzantine empires.
● The Muslims invaded Egypt, overthrew the unpopular Byzantine rulers, made a treaty with Nubia, and gradually assimilated both countries to Arab culture and Islamic religion. The conquest of north Africa followed, and then Spain.
● The Muslim empire soon fragmented and its centre of power shifted from Arabia to Syria to Baghdad in Iraq. In north Africa smaller kingdoms rose and fell and successive empires were founded by groups of Berber Islamic militants.
● The first African Islamic dynasty were the Fatimids, who came to power through the Shiite movement and ruled from Egypt to Morocco in the 10th to 12th centuries.
● In the mid-11th century there were further disruptive invasions by Arab herders and the Almoravids established Morocco as the centre for an empire over the Maghrib and Spain.
● The Almohads, inspired by the Islamic Sufi movement, succeeded them from the mid-12th to mid-13th century.

Egypt became a great centre of Islamic culture.
● In the wars against the Crusaders the Kurdish general Saladin took control of Egypt in 1171.
● His successors employed an army of Asian slaves who formed the Mamluk military regime which ruled Egypt until 1517.

Kanem was a trading kingdom, contemporary with Ghana.
● It reached the height of its power in the 13th century before destroying itself through civil war.

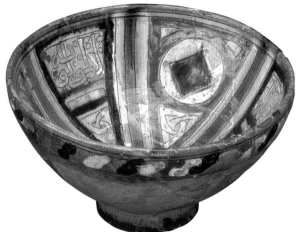

Pottery from Egypt

Fine pottery objects from Fustat south of Cairo are evidence of African mass production for a thriving export trade from about 1000 to the early 16th century. Styles changed with the times, from so-called 'Fatimid' to 'Mamluk', like this 14th-century bowl with Mamluk inscriptions. They even made imitations of Chinese export porcelain.

... and from African Spain

The Spanish pottery which developed in the period of African Muslim rule continued in production after the Christian conquests during the 15th century. This plate from Valencia from the first half of the 15th century is Islamic in style but Christian in theme, with human images (usually avoided by Muslims) in a Mediterranean galley with oars and sail.

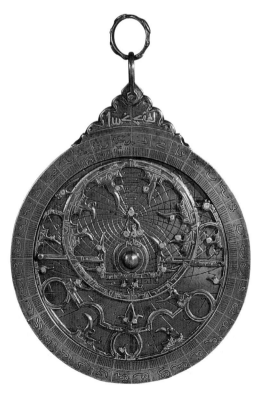

Islamic science and magic

Islamic civilisation was built upon cosmological traditions which can be traced back to ancient Egypt, Greece, Iran and India, and it made an essential contribution to the later development of the European culture of science.

Astrolabes like this, made in Syria in the 13th century, were for plotting the relative positions of the sun, moon and stars in order to tell the time and to navigate the oceans. Such instruments, with magic bowls and talismanic plaques for divination and finding treasure, were familiar to educated people from Spain through north Africa to southwest Asia and India.

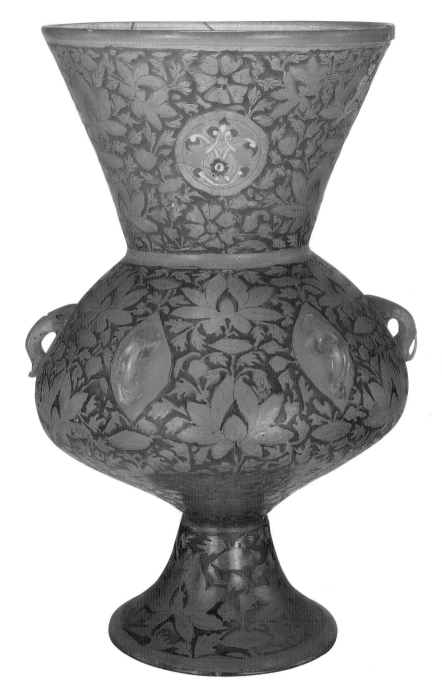

Africa . . . or Asia?

Painted glass lamps like this, made while Egypt was under the rule of the Mamluks, bear dedication texts and heraldic motifs showing the Mamluk identities of the men who presented them to mosques in Cairo or Damascus. The fact that such objects can be labelled 'Egypt or Syria' shows how integrated parts of Africa were with the regions beyond. Many such things came to the British Museum via collectors or dealers who had less interest in their history than in their artistic value, and their origins are often identified only from similarities with archaeological fragments.

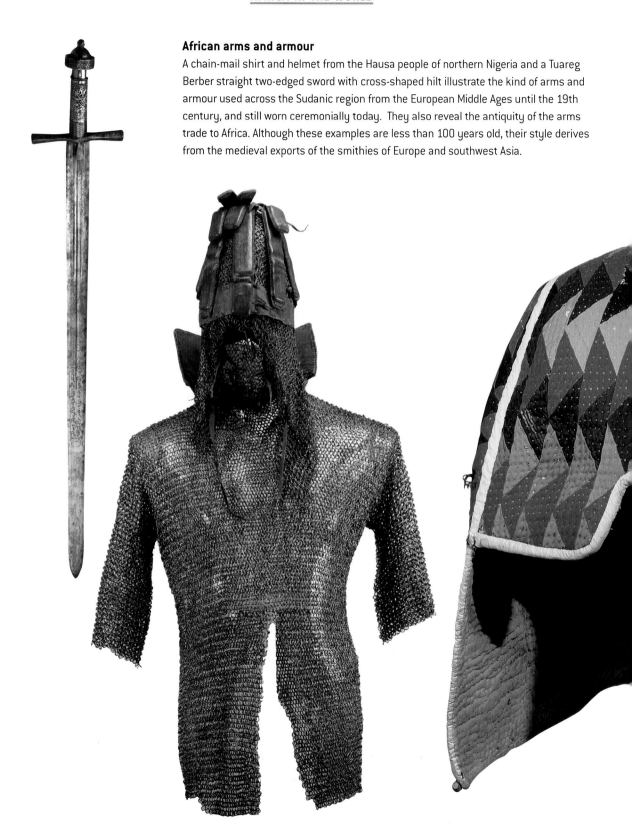

African arms and armour
A chain-mail shirt and helmet from the Hausa people of northern Nigeria and a Tuareg Berber straight two-edged sword with cross-shaped hilt illustrate the kind of arms and armour used across the Sudanic region from the European Middle Ages until the 19th century, and still worn ceremonially today. They also reveal the antiquity of the arms trade to Africa. Although these examples are less than 100 years old, their style derives from the medieval exports of the smithies of Europe and southwest Asia.

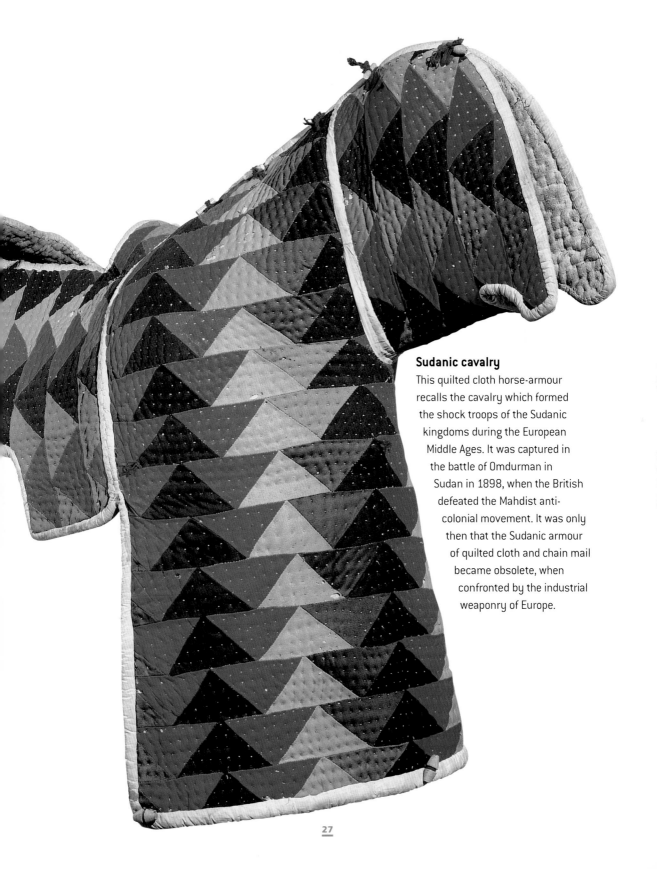

Sudanic cavalry

This quilted cloth horse-armour recalls the cavalry which formed the shock troops of the Sudanic kingdoms during the European Middle Ages. It was captured in the battle of Omdurman in Sudan in 1898, when the British defeated the Mahdist anti-colonial movement. It was only then that the Sudanic armour of quilted cloth and chain mail became obsolete, when confronted by the industrial weaponry of Europe.

4

AFRICA AND ASIA

What was Africa's relationship with the East?

While the kingdoms and empires of northern and
western Africa were built on trade across the Sahara
to the Mediterranean, trade around the shores of
the Indian Ocean brought prosperity to the peoples
of eastern Africa.

By the Christian era the African coasts from
Egypt to Mozambique and Madagascar were part of
a vast network of maritime trade with links to Arabia,
India, southeast Asia and China. The region was also
linked to north Africa and Europe through the countries of
the eastern Mediterranean, particularly Egypt.

The Indian Ocean trade brought distant peoples to the
east African coasts. They introduced new crops which
spread across the continent with the expanding Bantu
peoples. New Asian-African cultures developed, including
the Malagasy of Madagascar, and the Swahili, who built
great trading cities from Somalia to southern Tanzania.
The inland people, unaware of the export value of their
gold and ivory, gained far less than the coastal
merchants. But for all their prosperity, these merchant
peoples did not have the military power to resist the
marauding Portuguese voyagers, who conquered and
despoiled them in the early 16th century.

From India . . .

African trade with India goes back at least to the 10th
century AD, when dyed and printed cloth was being
imported to Egypt and the Red Sea coasts. By this time
the Malagasy people, traders from southeast Asia who
intermarried with coastal east Africans, were already
settling on the island of Madagascar, bringing with
them the culture of the Indian Ocean.

A 19th-century piece of aristocratic regalia from the
Merina people of Madagascar includes gilded plate metal

imported probably from Europe. But the coloured glass
gems were inspired by trading relationships with India
going back many centuries before it was made.

From Arabia . . .

This chair from Zanzibar reveals techniques of carpentry,
inlay and woven cane which derive from Arabia and India
rather than from elsewhere in Africa. Although made in
the 20th century, it reflects a style of furniture going
back hundreds of years in the history of the Swahili
people of the east African coasts.

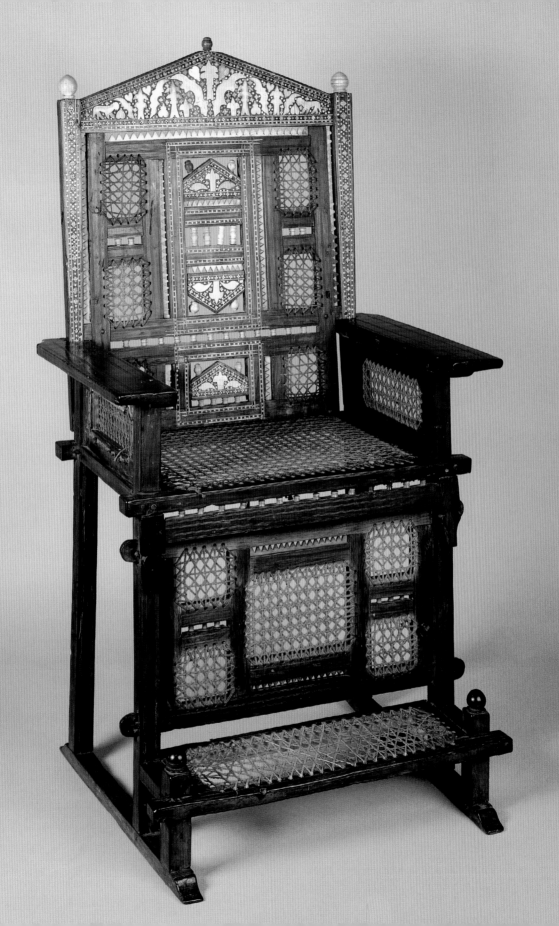

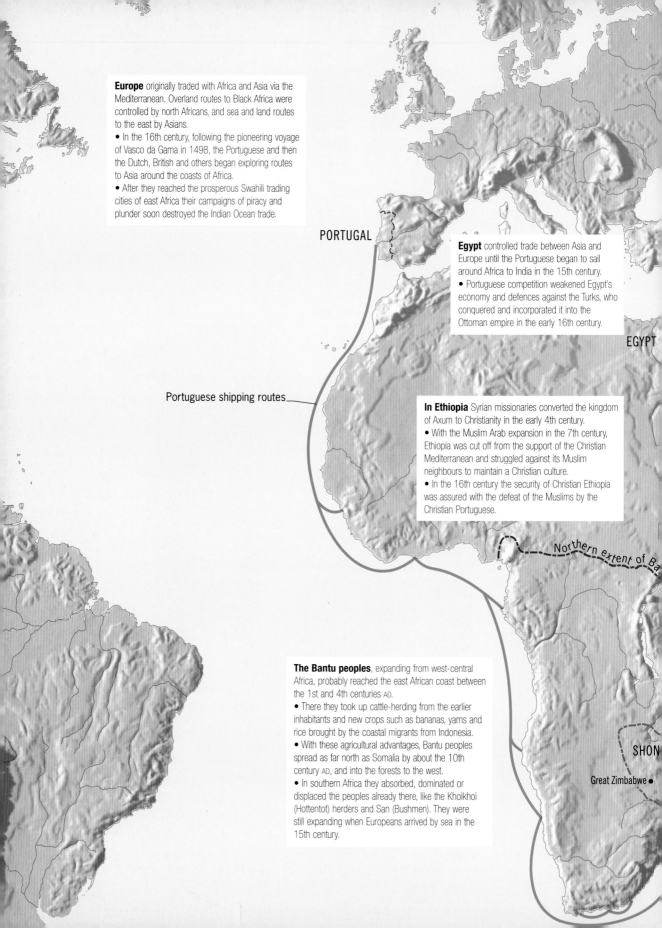

Europe originally traded with Africa and Asia via the Mediterranean. Overland routes to Black Africa were controlled by north Africans, and sea and land routes to the east by Asians.
• In the 16th century, following the pioneering voyage of Vasco da Gama in 1498, the Portuguese and then the Dutch, British and others began exploring routes to Asia around the coasts of Africa.
• After they reached the prosperous Swahili trading cities of east Africa their campaigns of piracy and plunder soon destroyed the Indian Ocean trade.

PORTUGAL

Egypt controlled trade between Asia and Europe until the Portuguese began to sail around Africa to India in the 15th century.
• Portuguese competition weakened Egypt's economy and defences against the Turks, who conquered and incorporated it into the Ottoman empire in the early 16th century.

EGYPT

Portuguese shipping routes

In Ethiopia Syrian missionaries converted the kingdom of Axum to Christianity in the early 4th century.
• With the Muslim Arab expansion in the 7th century, Ethiopia was cut off from the support of the Christian Mediterranean and struggled against its Muslim neighbours to maintain a Christian culture.
• In the 16th century the security of Christian Ethiopia was assured with the defeat of the Muslims by the Christian Portuguese.

Northern extent of Ba

The Bantu peoples, expanding from west-central Africa, probably reached the east African coast between the 1st and 4th centuries AD.
• There they took up cattle-herding from the earlier inhabitants and new crops such as bananas, yams and rice brought by the coastal migrants from Indonesia.
• With these agricultural advantages, Bantu peoples spread as far north as Somalia by about the 10th century AD, and into the forests to the west.
• In southern Africa they absorbed, dominated or displaced the peoples already there, like the Khoikhoi (Hottentot) herders and San (Bushmen). They were still expanding when Europeans arrived by sea in the 15th century.

SHON

Great Zimbabwe •

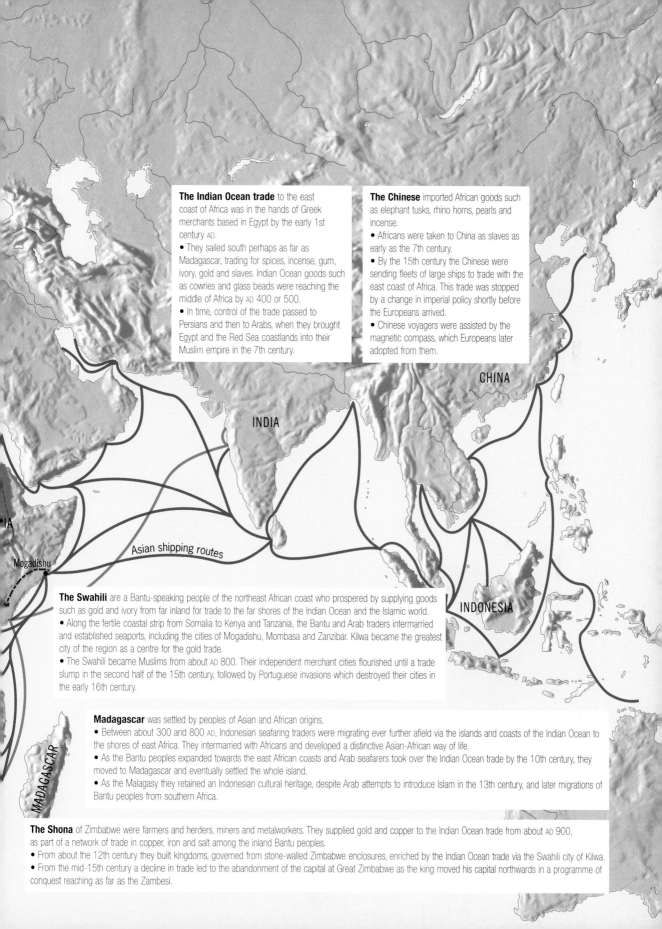

The Indian Ocean trade to the east coast of Africa was in the hands of Greek merchants based in Egypt by the early 1st century AD.

• They sailed south perhaps as far as Madagascar, trading for spices, incense, gum, ivory, gold and slaves. Indian Ocean goods such as cowries and glass beads were reaching the middle of Africa by AD 400 or 500.

• In time, control of the trade passed to Persians and then to Arabs, when they brought Egypt and the Red Sea coastlands into their Muslim empire in the 7th century.

The Chinese imported African goods such as elephant tusks, rhino horns, pearls and incense.

• Africans were taken to China as slaves as early as the 7th century.

• By the 15th century the Chinese were sending fleets of large ships to trade with the east coast of Africa. This trade was stopped by a change in imperial policy shortly before the Europeans arrived.

• Chinese voyagers were assisted by the magnetic compass, which Europeans later adopted from them.

CHINA

INDIA

Asian shipping routes

Mogadishu

INDONESIA

The Swahili are a Bantu-speaking people of the northeast African coast who prospered by supplying goods such as gold and ivory from far inland for trade to the far shores of the Indian Ocean and the Islamic world.

• Along the fertile coastal strip from Somalia to Kenya and Tanzania, the Bantu and Arab traders intermarried and established seaports, including the cities of Mogadishu, Mombasa and Zanzibar. Kilwa became the greatest city of the region as a centre for the gold trade.

• The Swahili became Muslims from about AD 800. Their independent merchant cities flourished until a trade slump in the second half of the 15th century, followed by Portuguese invasions which destroyed their cities in the early 16th century.

Madagascar was settled by peoples of Asian and African origins.

• Between about 300 and 800 AD, Indonesian seafaring traders were migrating ever further afield via the islands and coasts of the Indian Ocean to the shores of east Africa. They intermarried with Africans and developed a distinctive Asian-African way of life.

• As the Bantu peoples expanded towards the east African coasts and Arab seafarers took over the Indian Ocean trade by the 10th century, they moved to Madagascar and eventually settled the whole island.

• As the Malagasy they retained an Indonesian cultural heritage, despite Arab attempts to introduce Islam in the 13th century, and later migrations of Bantu peoples from southern Africa.

MADAGASCAR

The Shona of Zimbabwe were farmers and herders, miners and metalworkers. They supplied gold and copper to the Indian Ocean trade from about AD 900, as part of a network of trade in copper, iron and salt among the inland Bantu peoples.

• From about the 12th century they built kingdoms, governed from stone-walled Zimbabwe enclosures, enriched by the Indian Ocean trade via the Swahili city of Kilwa.

• From the mid-15th century a decline in trade led to the abandonment of the capital at Great Zimbabwe as the king moved his capital northwards in a programme of conquest reaching as far as the Zambesi.

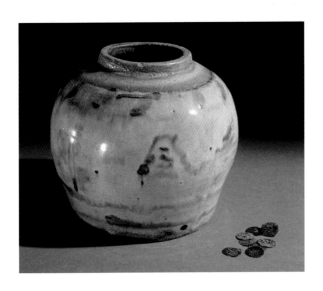

From China . . .

This Chinese stoneware pot, found in Somalia, contained 15th-century coins issued by the Sultan of Mogadishu. Another hoard from Tanzania included Chinese coins from the 13th century and local coins from Zanzibar from the 14th century.

Fragments of Chinese porcelain have been found in Africa as far south as Great Zimbabwe, the stone-walled Shona royal residence after which the present-day country is named. Chinese coins were exported in great quantities after the Chinese themselves adopted paper money during the 12th century, and were used from east and southeast Asia to the Indian Ocean, including the east coast of Africa.

. . . or perhaps not

Chinese porcelain was imitated by potters in many places between its source and its furthest destination in Africa. 'China' like this 9th-century Tang dynasty bowl, found in Iran, was also traded to the coasts of east Africa, as no doubt were the imitations of it made in Iran and Iraq.

By the late 14th century the Fustat potteries in Egypt were making cheap substitutes for Chinese blue and white porcelain, like this fragment of an imitation Ming dynasty pot.

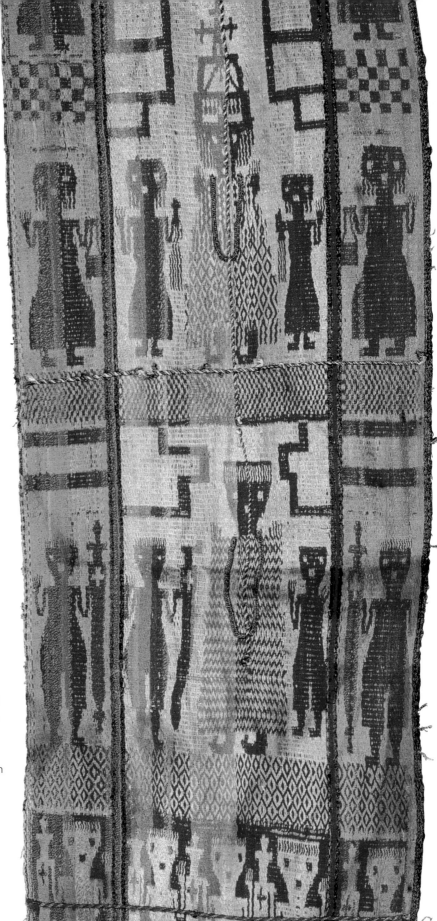

Interwoven traditions

The Indian Ocean trade contributed to the multicultural traditions of many African societies long after it was taken over by European merchants from the 16th century. This 18th century hanging depicts the Christian funeral of a king of Ethiopia, but it is made of silk from China, probably by Jewish weavers resident in the Ethiopian town of Gondar.

5

AFRICA AND GLOBALISATION

What did Africa contribute to the modern world?

Africans played a central role in the development of global markets and empires, which began when Europeans started trading and conquering around the world from about 500 years ago. The greatest benefits went to Europeans and Euro-Americans, while Africans and African-Americans paid the highest price.

In the second half of the 15th century European merchants arrived by ship around the coasts of west Africa as far south as Kongo, trading manufactured goods such as cloth for raw materials of gold, ivory and pepper, and people as slaves. As European colonists began to develop plantations in the Americas during the 16th century, slaves became most profitable. By the 18th century they were Africa's main export in the triangular trade between the three continents. The wealth created by these African exiles had a major impact on world history.

The slave trade...

● Enabled some Africans to develop powerful federations, kingdoms and empires by despoiling their neighbours.

● Helped Europeans to colonise and exploit the resources of the Americas.

● Enriched the countries of Europe and provided the capital which enabled them to industrialise and later to colonise and dominate other regions of the world.

● Introduced Native American crops such as maize and cassava which spread throughout Africa to become staple foods.

● Promoted the sharing of culture between the peoples of the three continents.

● Left a legacy of unequal development and racism which still persists in Europe, Africa and the Americas.

European seafaring

This mechanical model was made in Germany in the late 16th century. It is an unusual illustration of the ships which carried European explorers and traders around the world in that period, and of the developing technology which enabled them to do so. European success depended above all on effective navigational aids and superior weaponry, like the cannons shown on the model.

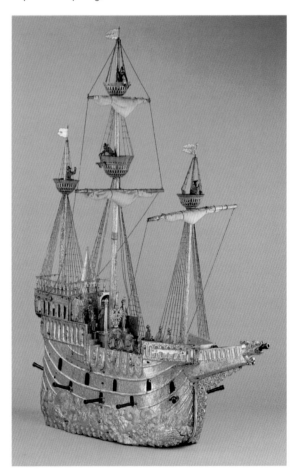

	EUROPE	AFRICA	AMERICAS
1500	**Mid-15th century** Wars of the Roses **1492** Christians complete the conquest of Muslim Spain **16th century** Tudor dynasty rules England	**Mid-15th century** Benin empire formed **1498** Vasco da Gama sails to east Africa **16th century** Portuguese trade with Kongo	**Mid-15th century** Aztecs and Incas **1492** Arrival of Columbus **1518** Arrival of first African slaves
1550			
1600		**Late 16th century** Portuguese advance into Angola **1591** Songai empire falls **Early 17th century** Portuguese despoil Swahili towns and take over southeast Africa gold trade	**Early 17th century** Europeans found colonies in north America
1650	**1640–49** English Civil War	**Mid-17th century** Dutch settle at the Cape	
1700		**Early 18th century** Asante begin building their empire	
1750	**1760s** Industrial Revolution begins in Britain **1789** French Revolution **1792** Beginning of the end of slave trade	**Mid-18th century** Oyo Yoruba empire expands	**1776** USA declares independence **1789** Haiti slave revolt
1800	**Early 19th century** Napoleonic Wars **1848** Popular uprisings	**1830** Export of slaves from east Africa to Americas begins	
1850			**1861–5** American Civil War, followed by slave emancipation

Europeans in Africa

A 16th-century brass figure
from Benin in southeast Nigeria
shows one of the soldiers who
accompanied the Portuguese
traders on their voyages
around the coasts of west Africa.
His armour and his flintlock gun,
as well as the pistol and crossbow
shown on the base, help explain
European success in capturing
distant markets in this period.

Much of the brass used to cast
such objects for the Benin royal
palace was imported from Europe.
Although not heavily involved in
the Atlantic slave trade,
Benin profited from the
same trade network.

Africans in America

This drum is the kind made by the Akan
peoples of Ghana such as the Asante.
It belongs to the collection with which the
British Museum was founded in 1753, and
the catalogue reads '1368 An Indian drum
made of a hollowed tree carv'd the top
being braced with peggs and thongs with
the bottom hollow from Virginia'. It must
have been made or brought from Africa
by an Akan slave.

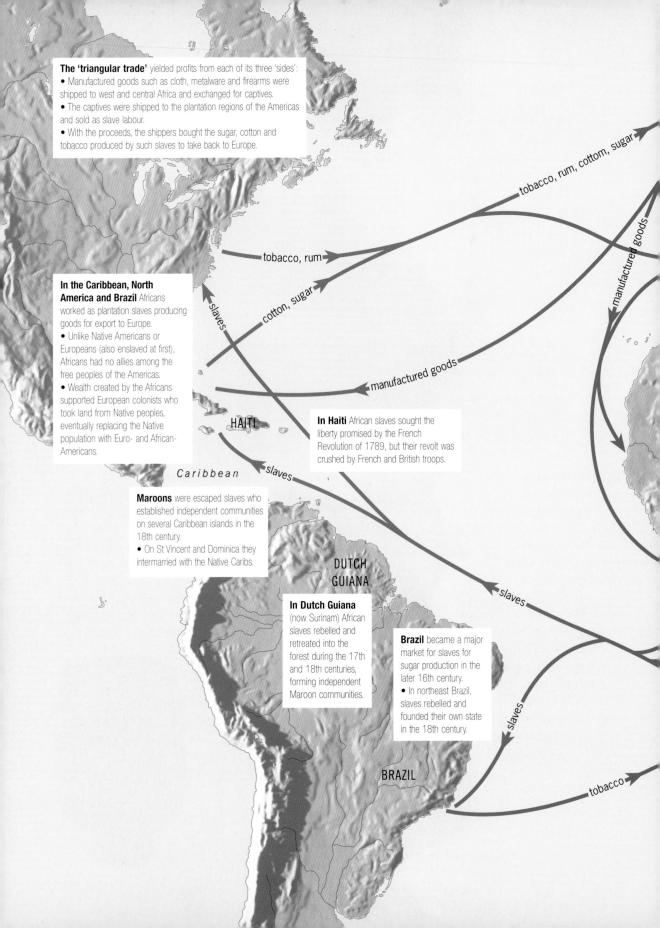

The 'triangular trade' yielded profits from each of its three 'sides':
• Manufactured goods such as cloth, metalware and firearms were shipped to west and central Africa and exchanged for captives.
• The captives were shipped to the plantation regions of the Americas and sold as slave labour.
• With the proceeds, the shippers bought the sugar, cotton and tobacco produced by such slaves to take back to Europe.

In the Caribbean, North America and Brazil Africans worked as plantation slaves producing goods for export to Europe.
• Unlike Native Americans or Europeans (also enslaved at first), Africans had no allies among the free peoples of the Americas.
• Wealth created by the Africans supported European colonists who took land from Native peoples, eventually replacing the Native population with Euro- and African-Americans.

In Haiti African slaves sought the liberty promised by the French Revolution of 1789, but their revolt was crushed by French and British troops.

Maroons were escaped slaves who established independent communities on several Caribbean islands in the 18th century.
• On St Vincent and Dominica they intermarried with the Native Caribs.

In Dutch Guiana (now Surinam) African slaves rebelled and retreated into the forest during the 17th and 18th centuries, forming independent Maroon communities.

Brazil became a major market for slaves for sugar production in the later 16th century.
• In northeast Brazil, slaves rebelled and founded their own state in the 18th century.

tobacco, rum, cottom, sugar

tobacco, rum

cotton, sugar

manufactured goods

manufactured goods

slaves

slaves

slaves

slaves

slaves

tobacco

HAITI

Caribbean

DUTCH GUIANA

BRAZIL

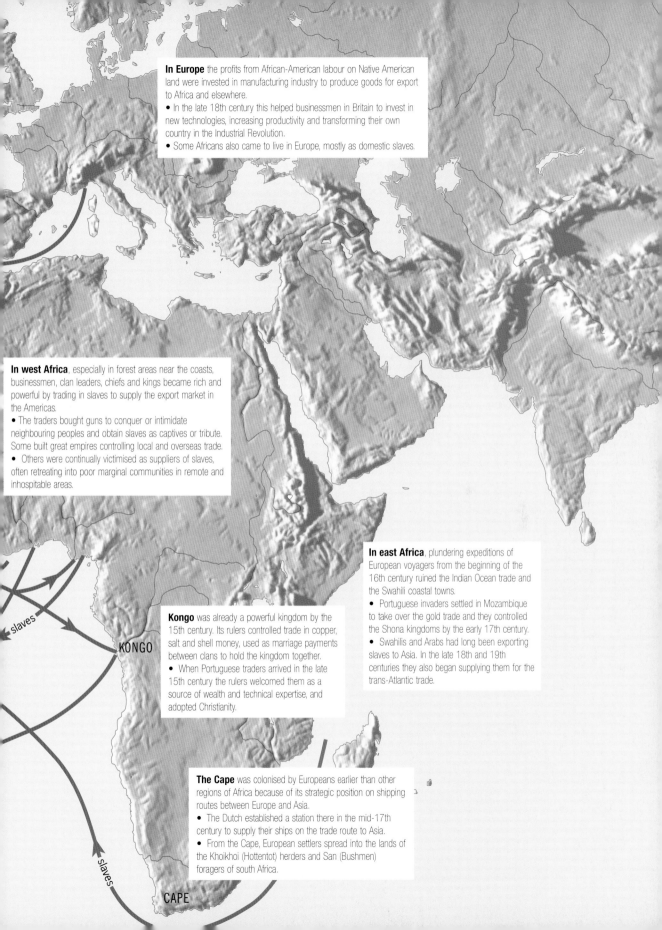

In Europe the profits from African-American labour on Native American land were invested in manufacturing industry to produce goods for export to Africa and elsewhere.
• In the late 18th century this helped businessmen in Britain to invest in new technologies, increasing productivity and transforming their own country in the Industrial Revolution.
• Some Africans also came to live in Europe, mostly as domestic slaves.

In west Africa, especially in forest areas near the coasts, businessmen, clan leaders, chiefs and kings became rich and powerful by trading in slaves to supply the export market in the Americas.
• The traders bought guns to conquer or intimidate neighbouring peoples and obtain slaves as captives or tribute. Some built great empires controlling local and overseas trade.
• Others were continually victimised as suppliers of slaves, often retreating into poor marginal communities in remote and inhospitable areas.

In east Africa, plundering expeditions of European voyagers from the beginning of the 16th century ruined the Indian Ocean trade and the Swahili coastal towns.
• Portuguese invaders settled in Mozambique to take over the gold trade and they controlled the Shona kingdoms by the early 17th century.
• Swahilis and Arabs had long been exporting slaves to Asia. In the late 18th and 19th centuries they also began supplying them for the trans-Atlantic trade.

Kongo was already a powerful kingdom by the 15th century. Its rulers controlled trade in copper, salt and shell money, used as marriage payments between clans to hold the kingdom together.
• When Portuguese traders arrived in the late 15th century the rulers welcomed them as a source of wealth and technical expertise, and adopted Christianity.

KONGO

slaves

The Cape was colonised by Europeans earlier than other regions of Africa because of its strategic position on shipping routes between Europe and Asia.
• The Dutch established a station there in the mid-17th century to supply their ships on the trade route to Asia.
• From the Cape, European settlers spread into the lands of the Khoikhoi (Hottentot) herders and San (Bushmen) foragers of south Africa.

slaves

CAPE

PORTUGAL

TUNIS

ALGIERS

MOROCCO

European slaves were captured in hundreds of thousands during the 16th and 17th centuries, by 'corsair' privateers sanctioned by the rulers of Morocco, Tunis and Algiers to raid the coasts and seaways of Italy, France and Britain.
• The captives made a major contribution to the economies of these countries, which suffered from continued enmity with the trading powers of Europe.
• Many Europeans remained in north Africa willingly, protected by the rights of slaves under Islamic law.

The Royal Africa Company was granted a charter by the British crown in 1672 to trade in gold and slaves along the Gold Coast (now Ghana). The die for its seal bears the legend BY ROYAL PATRONAGE TRADE FLOURISHES, BY THE TRADE OF THE REALM.

DAHOMEY

OYO

ASANTE

BENIN

KALABARI

KON

NDON

The Asante of Ghana from the beginning of the 18th century used the guns acquired in trade to take over older trading states on the Gold Coast.
• They took control of the European trade, set up an independent federation under a king, and built an empire by conquering their neighbours.
• The Asante acquired slaves as captives or tribute and incorporated them into the kingdom or sold them for export overseas.

Oyo is a Yoruba kingdom in Nigeria which expanded from the mid-16th century.
• It purchased cavalry from the Sudanic region to the north for manufactured goods obtained by trading slaves to Europeans on the coast to the south.
• Oyo obtained slaves as tribute from conquered peoples. These included the Fon of Dahomey, who struggled to maintain their own independent trading kingdom which captured slaves from their neighbours.

Benin in Nigeria was probably the only coastal state in west Africa before the Europeans arrived in the 15th century.
• It was the first kingdom to obtain guns, by trading goods such as pepper to the Portuguese.
• Benin's trade declined during the 18th century with the rise of slave exports by the Yoruba and Niger Delta peoples.

The Kalabari and other independent fishing peoples of the Niger delta began to sell captives and slaves traded from inland to Europeans in return for goods such as guns and cloth.
• By the 18th century their powerful clan trading corporations played a major part in the 'triangular trade'.

Ndongo was a kingdom taken over in the late 16th century by the Portuguese, who then advanced into Angola.
• Imbangala raiders took over the outlying areas of the Kongo and Ndongo kingdoms to supply the slave trade.

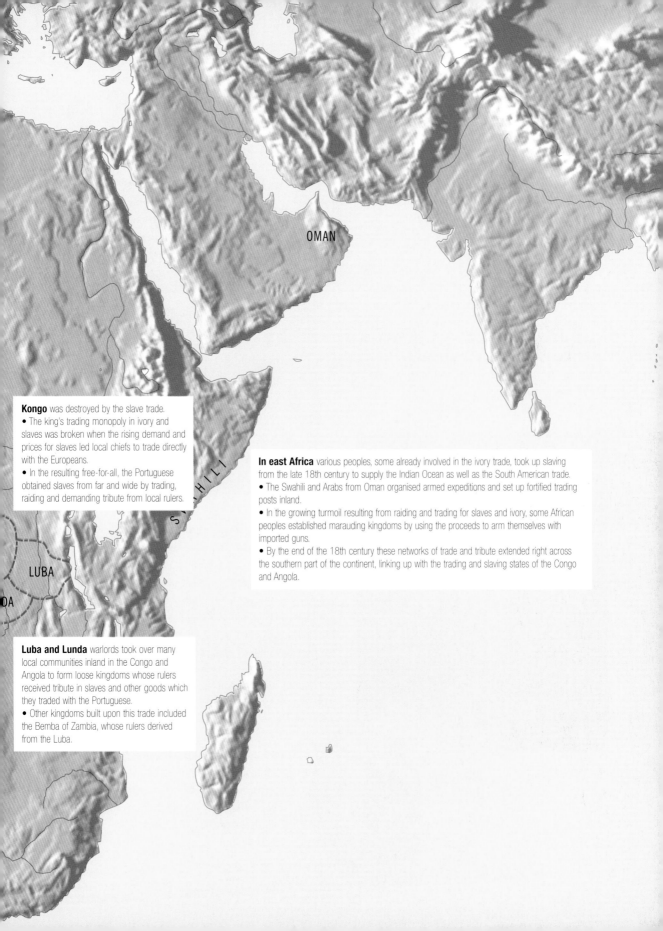

OMAN

Kongo was destroyed by the slave trade.
• The king's trading monopoly in ivory and slaves was broken when the rising demand and prices for slaves led local chiefs to trade directly with the Europeans.
• In the resulting free-for-all, the Portuguese obtained slaves from far and wide by trading, raiding and demanding tribute from local rulers.

In east Africa various peoples, some already involved in the ivory trade, took up slaving from the late 18th century to supply the Indian Ocean as well as the South American trade.
• The Swahili and Arabs from Oman organised armed expeditions and set up fortified trading posts inland.
• In the growing turmoil resulting from raiding and trading for slaves and ivory, some African peoples established marauding kingdoms by using the proceeds to arm themselves with imported guns.
• By the end of the 18th century these networks of trade and tribute extended right across the southern part of the continent, linking up with the trading and slaving states of the Congo and Angola.

S W A H I L I

LUBA

DA

Luba and Lunda warlords took over many local communities inland in the Congo and Angola to form loose kingdoms whose rulers received tribute in slaves and other goods which they traded with the Portuguese.
• Other kingdoms built upon this trade included the Bemba of Zambia, whose rulers derived from the Luba.

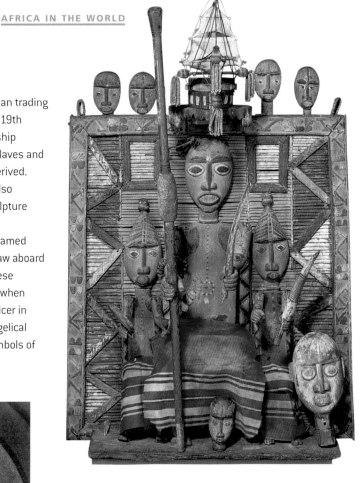

African slavers

This screen is a memorial to an ancestor of a clan trading house of the Kalabari people, dating to the late 19th century. The ancestor himself wears a sailing ship headdress, symbolic of the overseas trade in slaves and later palm oil from which Kalabari prosperity derived. It represents the masquerade he performed (also portrayed in a modern version by the steel sculpture on page 61).

Such screens were modelled on European framed portraits which their makers, the local pilots, saw aboard the ships they guided to harbour. Several of these treasured objects came to the British Museum when their owners gave them to a British colonial officer in 1916, to save them from a local Christian evangelical movement which was intent on destroying symbols of the ancestral religion.

From prince to slave to abolitionist

In the 1740s William Ansah was sent as an emissary to London by his father Eno Baisie Kurentsi, the slave-trading king of Akwa on the 'Slave Coast' of west Africa (part of modern Ghana). But the captain of his ship sold him in the Caribbean, where four years as a plantation slave gave him a new perspective on slavery. When Ansah's father eventually secured his freedom and he reached London, he helped to publicise the cruelties of the slave trade. Gabriel Mathias painted his portrait, which was used to produce this mezzotint engraving.

'Am I not a man and a brother?'

The famous slogan, with an image of an African man in chains, appears on a medallion made in 1787 for the foundation of the Society for the Suppression of the African Slave Trade.

What was slavery?

Slavery in Africa was very different from slavery in the Americas. Slaves in Africa were those forced to work, often in communities other than their own, to repay debts, to atone for crimes, or as war captives or tribute. Slaves held by ordinary people might become members of the family, but powerful chiefs and kings held greater numbers who worked for them in occupations such as farming or mining. Rulers sometimes imported whole communities of conquered people to work for them as serfs, who might eventually become full citizens of the kingdom. Slaves, lacking full civil rights, were those most likely to be given as tribute or sold for the overseas slave trade. But the export market also encouraged Africans to capture people for sale.

The European market treated slaves as commodities to be bought and sold for their labour with minimal civil rights. The brutality of capture and shipment from Africa to the Americas, the forced labour, early deaths and savage punishments for resistance were made public knowledge in Europe by the anti-slavery movement in the 18th century. The racism which treated Africans as inferior in culture, intelligence and humanity, justified Europeans in enslaving and later colonising them. It continues to colour relationships between Africans and Europeans to this day.

How can we understand the history of slavery?

One way to change the racist perspective of the slaving past is to focus less on the suffering of Africans as victims and more on their efforts to fight against cruelty and injustice. Africans struggled against their oppression from the beginning to the end of slavery in the Americas, by every means from passive resistance and workplace sabotage to subversive art. There were escapes, attacks on slave owners and open rebellions. In the Caribbean slave uprisings were a frequent occurrence, despite the price of failure being death, often by torture.

Some rebellions succeeded, for shorter or longer periods. By the 18th century there were free African 'Maroon' communities living independently of white planters and governments in Jamaica, Brazil and Surinam (Dutch Guiana). In the late 18th century the French Revolution inspired Africans to take over the French colony of Haiti and resist French and British armies. Such resistance hastened the end of slavery by undermining plantation profits as well as by publicising the injustices of the system.

Slave-owners tried to divide and rule Africans by suppressing their languages and culture, mixing up ethnic groups, splitting families and depriving them of time and leisure to develop their own communities and culture. But the Africans survived and reconstructed their lives, societies and values; an inspiring example of how humanity can transcend extremes of brutality and degradation. They achieved this by adopting and adapting the language and culture of their masters while retaining what they could of their ancestral cultures, to produce new Afro-European traditions in the Americas. The legacy of subjugation continues, in the Americas and in Europe, but the descendants of the slaves have not ceased to fight it.

The abolition of the slave trade

In the late 18th century European campaigners objecting to the inhumanity of slavery began to undermine the slave trade. By this time the economies of northern Europe, especially Britain, were beginning to industrialise, depending more on manufacturing and less on overseas plantation agriculture. European countries started to ban slave trading from 1792. Britain banned the trade in 1807 and led European naval campaigns to prevent it around the coasts of Africa. The mass export of African slaves finally ended in the 1860s, by which time the Europeans had changed to trading for industrial raw materials such as palm oil and rubber.

William Wilberforce and the abolitionists

This exhibit in the Wilberforce House museum in Hull shows the famous reformer himself. His house is now a museum illustrating the slave trade and the life, times and work of the Europeans who campaigned to abolish it.

The arms trade

The slave trade was accompanied by the sale of weapons far more effective than most African peoples could produce for themselves, particularly firearms. Long after the abolition of slavery, the arms trade still contributes to the destruction and misery of war in many African countries.

This sword, although European in style, was actually made in Kongo in the 15th or 16th century, modelled on Portuguese swords of the time. The hilt design appealed to the Kongo because it resembled carvings representing their ancestors, with one arm raised to the sky and the other lowered to the earth.

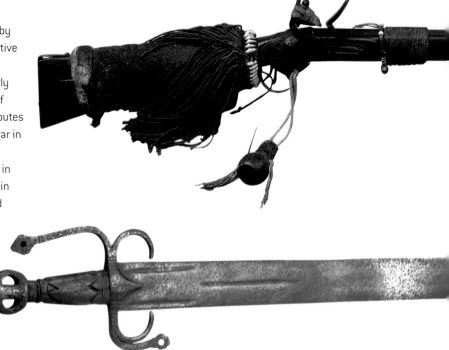

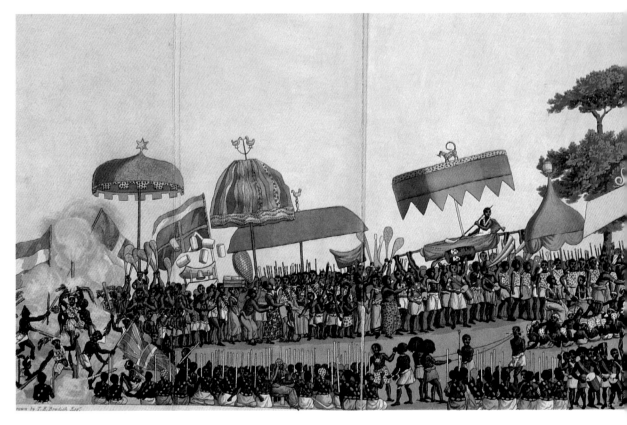

This flintlock 'Dane gun' is the kind which the Asante of Ghana imported from Europe to conquer their large empire and supply captives for export in the 18th and 19th centuries. Such guns are still used for ceremonial display at the Asante royal court.

'Mission to Ashantee'

When the Royal African Company sent T. E. Bowdich on a diplomatic visit to the kingdom of Asante on the Gold Coast in 1817, he was much impressed by its displays of court pageantry and wealth. The Asante and the British both valued their trade in gold and slaves for firearms and other manufactures, and Bowdich was sent home with official gifts, some for the British Museum. Bowdich's book *Mission to Ashantee*, illustrated from his own drawings, gave Europeans their first detailed account of the kingdom. In this scene, from a copy in the British Museum's library, his party have a place of honour witnessing a magnificent public procession of chiefs, their attendants, musicians and soldiers (armed with guns) for the annual yam-harvest festival.

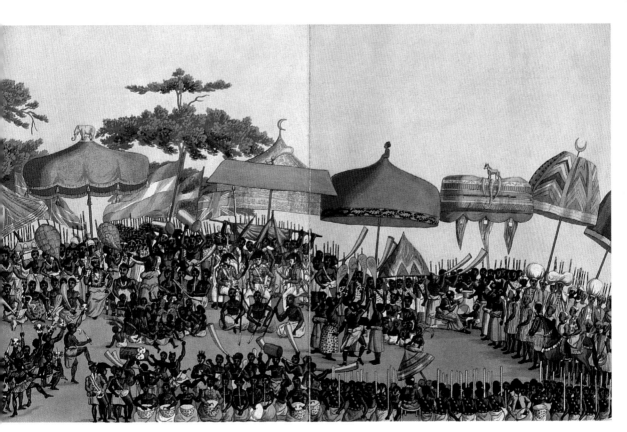

African slaves in Europe

Possessing Black slaves was a sign of wealth and status in 18th-century Europe, and something to be celebrated in art. This porcelain ornament, made in Germany in the 1750s, shows a wealthy woman with the train of her magnificent dress carried by a well-dressed domestic slave.

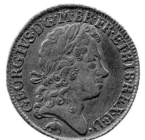
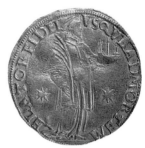

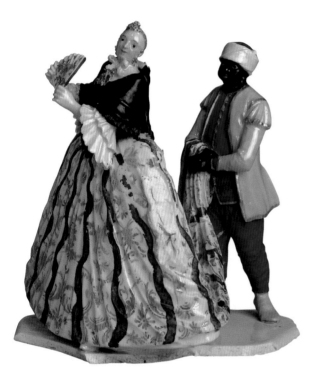

Coins of African gold. . .

From the mid-15th century Portuguese coins were made of African gold. This cruzado bears an abbreviation of the presumptuous title KING OF PORTUGAL, ALGARVE AND GUINEA, as a sign of Portuguese ambitions in west Africa. The British guinea coin took its name from the wealth-producing Guinea Coast of west Africa, source of both gold and slaves.

Discovering the history of slavery

The Merseyside Maritime Museum acknowledges Liverpools' debt to the trade on which its wealth was founded in its 'Transatlantic Slavery' exhibition, which includes these neck irons and chain.

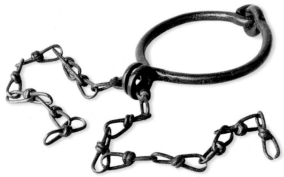

. . . and the currencies of Africa

Objects used for exchange within African societies were often prestige goods, given and received for specific purposes, but some were also traded with the Europeans.

Copper ingots from Katanga, the copper-producing area of the Congo, were used for ceremonial payments. Brass manila ingots, derived from bracelets, were used as currency in Nigeria from about the 16th century and later made in Europe to buy goods in Africa. They are shown in the brass plaques from the palace of Benin, and were melted down by the Benin brass-casters.

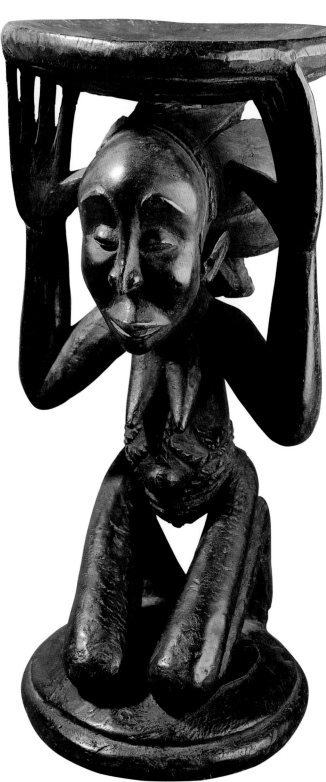

The ivory trade

Ivory jewellery, like this mid-19th century German brooch, illustrates another dimension of the Atlantic slave trade. In the late 18th and early 19th centuries new art fashions from Asia increased the demand for ivory in Europe. This coincided with new demands for slaves for plantations in the Indian Ocean, Zanzibar, Brazil and Cuba, now cut off from west Africa by the British suppression of the slave trade. The result was an expansion in slave and ivory trading by Swahili and Arab merchants who set up trade networks throughout east Africa.

The Luba kingdom

This throne was made in the 19th century for the Luba kingdom of the southwest Congo. From the 17th century, Luba kings took advantage of the turmoil caused by the Atlantic slave trade to incorporate neighbouring peoples into their kingdom. The spirits upholding their authority preferred to operate through women, who played an important part in the religious and administrative system. So images of women were carved for the regalia of kings and chiefs, like thrones used for important state ceremonies.

6

AFRICA AND COLONISATION

After the Atlantic slave trade ended in the second half of the 19th century, African exports shifted to raw materials for the industrial markets of Europe and north America. West Africans began supplying palm oil for soap, margarine and lubricants, while central Africans produced wild rubber and ivory. The African rulers who had monopolised the slave trade were undermined by the rise of new local entrepreneurs, and Christian missionaries began to offer new alternatives to discredited local religious and political systems.

Then a slowdown in industrial development, the 'Great Depression' of 1873, led to a shift in economic power from Britain to the United States and Germany, and a search for new markets, cheap labour and raw materials. While the United States and Russia expanded their boundaries across northern latitudes, European countries extended their control over southern regions, including Africa.

By this time Europeans had trading forts all around the African coasts and when disputes with local rulers gave a pretext for invasion these formed bases for expeditions inland. Industrial military technology ensured victory over the most determined African resistance. In southern Africa conquest was aided by European immigration. The colonial intention to secure supplies of raw materials and foodstuffs for European and North American industries required massive investment in African economic development. This only began to yield substantial returns in the mid-20th century, by which time Africans were campaigning for political independence. Colonial rule ended in most areas during the 1960s and '70s, but by then European and American companies had ensured that they would continue to receive the profits from their investments.

The British invasion of Asante. . .

This silver-gilt dish is a trophy of the colonial wars. The cast gold disc in the centre is a chest pendant worn by the young men who served as 'souls' for the king of Asante in Ghana, acting as messengers and informants while training for high office. It was part of a payment in gold which the British exacted from the king after they invaded Asante in 1874, capturing the capital Kumasi. The gold was purchased and exhibited by the London jewellers Garrards, who made the dish and sold it.

. . . and some of their allies

The Fante of coastal Ghana organised militia companies to control trade between Europeans and inland people such as the Asante. They sided with the British in their wars against the Asante in the late 19th century and it was then that this flag was made. Although it resembles a British ensign, the monkey design has a local proverbial meaning on the lines of 'look before you leap'.

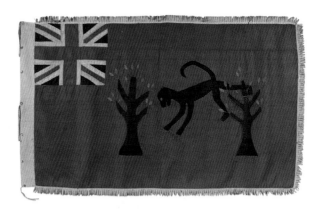

	AMERICAS	AFRICA	EUROPE
1880		**1880s–1890s** European states invade and conquer most of Africa. Anti-colonial movements form in Lagos and Freetown, Sierra Leone	**1884–5** Berlin conference to divide Africa into European colonies
1890			
1900		**1900s–1910s** Europeans set up colonial administrations and crush local resistance	
1910	**1910s–1920s** Pan-African movements in the USA	**1914–18** Africans fight for their European rulers in 1st World War	**1910** lst Pan-African Congress held in London
1920			**1914–18** Millions killed in 1st World War
			1919 Germany loses its African colonies
1930			
1940	**1942–45** African-Americans fight in the 2nd World War	**1939–45** Important 2nd World War campaigns fought in north Africa	**1939–45** 2nd World War devastates the continent
1950	**1950s** Caribbean countries begin to gain independence	**1950s** Resistance re-emerges in campaigns for the independence of new colonial countries	**1950s** Afro-Caribbeans arrive to meet the European need for labour
1960	**1960s** African-Americans campaign for civil rights and fight in Vietnam War	**1960s** The last British and French colonies become independent	
1970		**1976** Independence of Mozambique and Angola, followed by wars sponsored by South Africa	**1976** Portugal overthrows its dictatorship and abandons its African colonies
1980			
1990		**1994** End of White rule in South Africa	
2000	**2000s** United States is the richest country in the world. The Caribbean and South America much poorer	**2000s** Africa includes some of the poorest contries in the world, mostly in debt to Europe and North America	**2000s** Europe prospers, with some of the world's richest countries

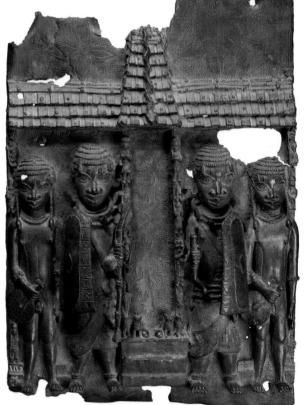

The conquest of Benin

An enormous quantity of brass and other objects were looted from the king's palace when the British conquered the kingdom of Benin in 1897. As much as possible was sold to recover the costs of the military expedition and the rest was given to the British Museum.

This is one of the 16th to 17th-century cast brass plaques which once decorated the palace. It shows the construction of the palace itself, with its wood-shingle roof and tower with a brass python, supported by posts covered with brass plaques.

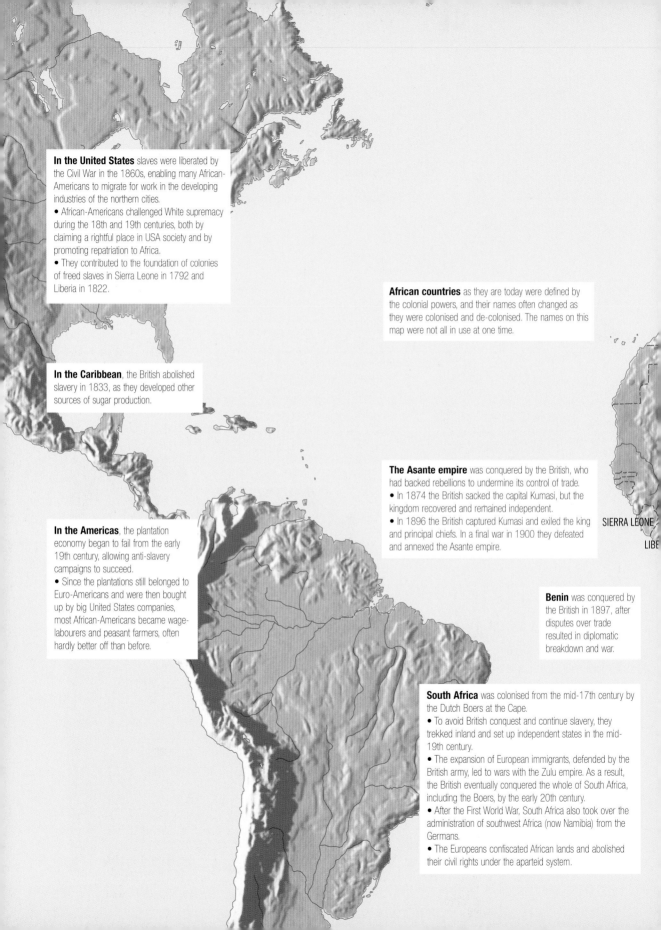

In the United States slaves were liberated by the Civil War in the 1860s, enabling many African-Americans to migrate for work in the developing industries of the northern cities.
● African-Americans challenged White supremacy during the 18th and 19th centuries, both by claiming a rightful place in USA society and by promoting repatriation to Africa.
● They contributed to the foundation of colonies of freed slaves in Sierra Leone in 1792 and Liberia in 1822.

African countries as they are today were defined by the colonial powers, and their names often changed as they were colonised and de-colonised. The names on this map were not all in use at one time.

In the Caribbean, the British abolished slavery in 1833, as they developed other sources of sugar production.

The Asante empire was conquered by the British, who had backed rebellions to undermine its control of trade.
● In 1874 the British sacked the capital Kumasi, but the kingdom recovered and remained independent.
● In 1896 the British captured Kumasi and exiled the king and principal chiefs. In a final war in 1900 they defeated and annexed the Asante empire.

SIERRA LEONE

LIBE

In the Americas, the plantation economy began to fail from the early 19th century, allowing anti-slavery campaigns to succeed.
● Since the plantations still belonged to Euro-Americans and were then bought up by big United States companies, most African-Americans became wage-labourers and peasant farmers, often hardly better off than before.

Benin was conquered by the British in 1897, after disputes over trade resulted in diplomatic breakdown and war.

South Africa was colonised from the mid-17th century by the Dutch Boers at the Cape.
● To avoid British conquest and continue slavery, they trekked inland and set up independent states in the mid-19th century.
● The expansion of European immigrants, defended by the British army, led to wars with the Zulu empire. As a result, the British eventually conquered the whole of South Africa, including the Boers, by the early 20th century.
● After the First World War, South Africa also took over the administration of southwest Africa (now Namibia) from the Germans.
● The Europeans confiscated African lands and abolished their civil rights under the aparteid system.

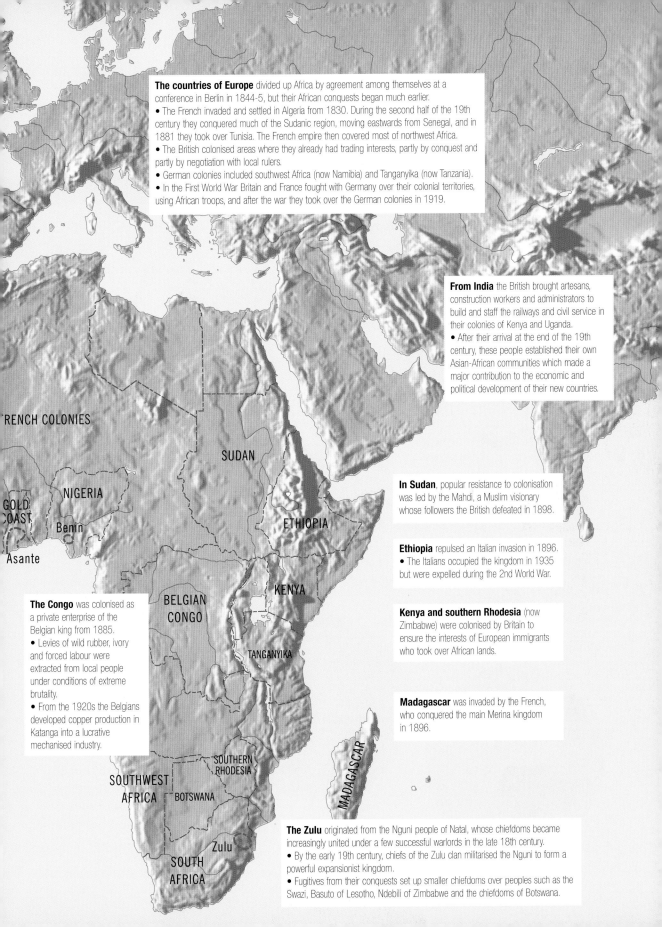

The countries of Europe divided up Africa by agreement among themselves at a conference in Berlin in 1844-5, but their African conquests began much earlier.
• The French invaded and settled in Algeria from 1830. During the second half of the 19th century they conquered much of the Sudanic region, moving eastwards from Senegal, and in 1881 they took over Tunisia. The French empire then covered most of northwest Africa.
• The British colonised areas where they already had trading interests, partly by conquest and partly by negotiation with local rulers.
• German colonies included southwest Africa (now Namibia) and Tanganyika (now Tanzania).
• In the First World War Britain and France fought with Germany over their colonial territories, using African troops, and after the war they took over the German colonies in 1919.

From India the British brought artesans, construction workers and administrators to build and staff the railways and civil service in their colonies of Kenya and Uganda.
• After their arrival at the end of the 19th century, these people established their own Asian-African communities which made a major contribution to the economic and political development of their new countries.

In Sudan, popular resistance to colonisation was led by the Mahdi, a Muslim visionary whose followers the British defeated in 1898.

Ethiopia repulsed an Italian invasion in 1896.
• The Italians occupied the kingdom in 1935 but were expelled during the 2nd World War.

Kenya and southern Rhodesia (now Zimbabwe) were colonised by Britain to ensure the interests of European immigrants who took over African lands.

The Congo was colonised as a private enterprise of the Belgian king from 1885.
• Levies of wild rubber, ivory and forced labour were extracted from local people under conditions of extreme brutality.
• From the 1920s the Belgians developed copper production in Katanga into a lucrative mechanised industry.

Madagascar was invaded by the French, who conquered the main Merina kingdom in 1896.

The Zulu originated from the Nguni people of Natal, whose chiefdoms became increasingly united under a few successful warlords in the late 18th century.
• By the early 19th century, chiefs of the Zulu clan militarised the Nguni to form a powerful expansionist kingdom.
• Fugitives from their conquests set up smaller chiefdoms over peoples such as the Swazi, Basuto of Lesotho, Ndebili of Zimbabwe and the chiefdoms of Botswana.

FRENCH COLONIES
SUDAN
GOLD COAST
NIGERIA
Benin
Asante
ETHIOPIA
KENYA
BELGIAN CONGO
TANGANYIKA
SOUTHWEST AFRICA
SOUTHERN RHODESIA
BOTSWANA
MADAGASCAR
Zulu
SOUTH AFRICA

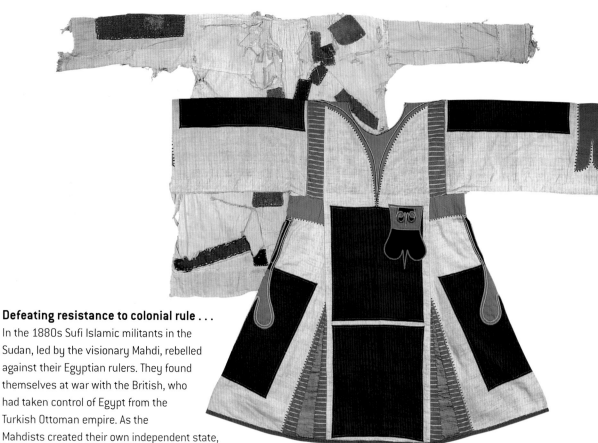

Defeating resistance to colonial rule . . .

In the 1880s Sufi Islamic militants in the
Sudan, led by the visionary Mahdi, rebelled
against their Egyptian rulers. They found
themselves at war with the British, who
had taken control of Egypt from the
Turkish Ottoman empire. As the
Mahdists created their own independent state,
their soldiers turned the ragged patched tunic of the first
unworldly militants into smart patched uniforms. This example
(shown with its ragged prototype) was captured at the battle of
Omdurman in 1898, when the British finally defeated the
Mahdists and colonised the Sudan.

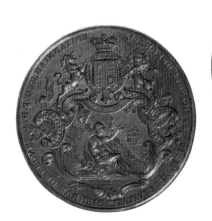

. . . putting the official stamp on it

With the European conquest of Africa,
the countries of origin and
destination of the Atlantic slave
trade were united in colonial
empires. These British seals for
stamping official documents
illustrate their shared history.
The Granada seal of 1838-9
shows a sugar mill, symbolic of the
wealth created by former slaves. The
Sierra Leone seal of the same date shows
a freed slave, representing the colonial
settlement of African-Americans in that
country by the British.

Justifying colonialism

Europeans treated the invasion of Africa not only as a matter of national interest but also as a mission to bring the benefits of Christian civilisation to 'the dark continent.' This conviction of cultural and moral superiority, closely identified with differences in appearance, first developed as a justification for the Atlantic slave trade. 17th-century slavers and planters convinced themselves that African slaves were sub-human, soulless heathens and hence without human rights. 18th-century scholars developed this theory from religious dogma to social philosophy. 19th-century intellectuals, exploring new fields such as evolution and anthropology, were sure they had confirmed European superiority as scientific fact. All the while, politicians and administrators were applying these ideas to European relationships with Africans, supporting subjugation and exploitation with physical force under the law.

One philosophical and scientific basis for this ideology of racism was the theory that physical characteristics, resulting from inherited membership of a 'race', determined people's social and cultural potential, hence their value and their human rights. Another, based on developing research into human history, held that different peoples were at different stages of development from savagery to civilisation. Unsurprisingly, Europeans came out top on both counts. They used these theories to justify an attitude of superiority over Africans, whether treating them as animals to be put to work as slaves, as victims to be emancipated from oppression, or as ignorant and childlike savages to be improved by colonial rule. The exaggerated insistence on the 'animal' or 'childlike' nature of Black people by many writers of colonial times betrays a certain anxiety about proving this point in the face of evidence to the contrary.

As a product of its times, this racism lost intellectual respectability during the late 20th century, with African national independence and immigration to Europe. But it has left a legacy in British, European and American culture, and not only among those Whites who seek Black scapegoats for their own problems. It also colours popular attitudes on issues such as cultural identity, immigration and Third World development, which still partly disguise First World self-interest.

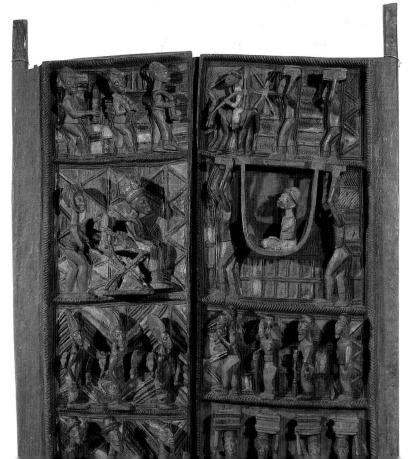

...and governing the colonies

This carved door was made for the king's palace of the Yoruba town of Ikere in southwest Nigeria. It shows the king in beaded crown, with attendants and wives above and below, receiving a British official, from whom he holds his authority under the colonial policy of 'indirect rule.' The official, as a man of rank, arrives in a litter with attendants and prisoners carrying boxes for collecting tax.

Remembering colonial wars

This medal was struck to commemorate General Gordon, who was killed in the siege of Khartoum in 1885 by Mahdist forces resisting British support for the Ottoman-Egyptian government of the Sudan. The back is inscribed: SENT BY THE GLADSTONE GOVERNMENT TO THE SOUDAN WITH ONE COMPANION, JANY. 1884. IN MARCH HE ASKED FOR 200 BRITISH TROOPS BUT WAS DELIBERATELY ABANDONED TO HIS FATE UNTIL TOO LATE.

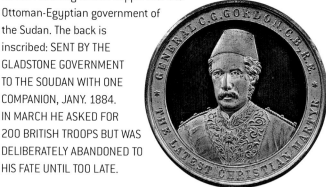

Discovering African histories

As Europeans took control of Africa for economic gain and political expediency, they also began to investigate its history and culture, writing reports and books and bringing home artefacts and photographs, which found their way into museums. Among these colonial researchers was Emil Torday, a Hungarian who left his job with the Belgian colonial authorities to travel and research among the peoples of the Congo in the 1900s. He took a particular interest in the Kuba kingdom and collected many of their artistic products for the British Museum.

This statue commemorates king Shyaam aMbul aNgoong, who established the kingdom of Kuba in the early 17th century. It shows the insignia of his rank and a game board, symbolic of victory in the political game which brought him to power. Each king since then has had such an image made to confer his vitality upon his successors. The Kuba say the carving is a portrait from life, while European scholars date it to the late 18th century. The Kuba king sold it to Torday in 1908 on the understanding that it would help the people of Europe to learn about his kingdom. Since then the oral history of the Kuba has become widely known through European research.

Documenting colonial history

The history of colonial conquest and rule is preserved in many museums and archives throughout Britain. The National Army Museum in London illustrates British campaigns with weapons, uniforms and mementoes of African and British regiments. In South Africa, Africans fought on both sides and this photo from 1879 shows men of the second Battalion Natal Native Contingent who fought with the British against the Zulus.

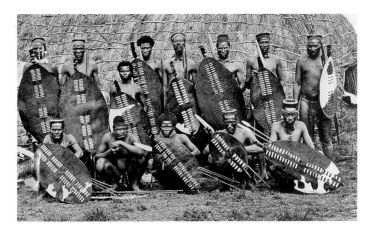

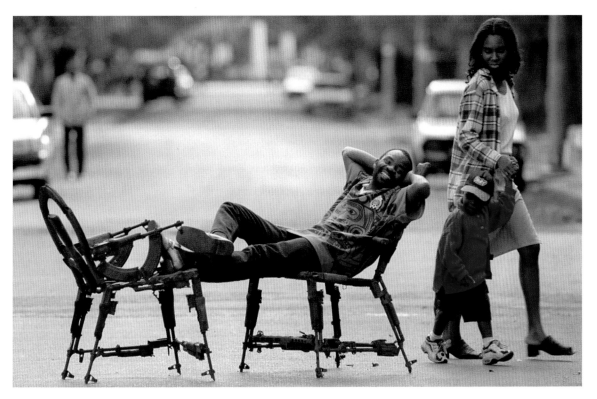

The cost of independence

Some African countries paid a heavy price to escape from colonial rule. Mozambique's independent socialist government was undermined by sixteen years of devastating civil war, sponsored by apartheid South Africa and Western interests. The brutality of the conflict is captured in chairs made in 2001 from guns handed in after the end of the war in 1992. The artist Kester, seen relaxing on his work, made these under a Christian Aid supported project 'transforming arms into ploughshares'. Weapons are turned into 'contemporary art', familiar in Maputo, the lively cosmopolitan capital of Mozambique.

Chairs and stools were symbols of political authority in many African societies, but these chairs, one of which is now in the British Museum, also testify to the international arms trade. They represent the political and commerical interests of Europe and America which have profited from conflict and death in Africa for centuries.

Africa in the British Museum

The British Museum displays the diverse cultural heritage of Africa to visitors from around the world. It covers thousands of years of history, and continues to collect the new cultural products of ever-changing African societies.

In Tanzania an artists' co-operative founded by Edward Said Tingatinga paints scenes representing the interests and concerns of contemporary urban life. *Dar es Salaam by Night* by Isa Saidi Mitole, purchased by the British Museum in 2002, satirises the sexual habits contributing to the epidemic of HIV/AIDS which has devastated Tanzania and other regions of Africa in recent years.

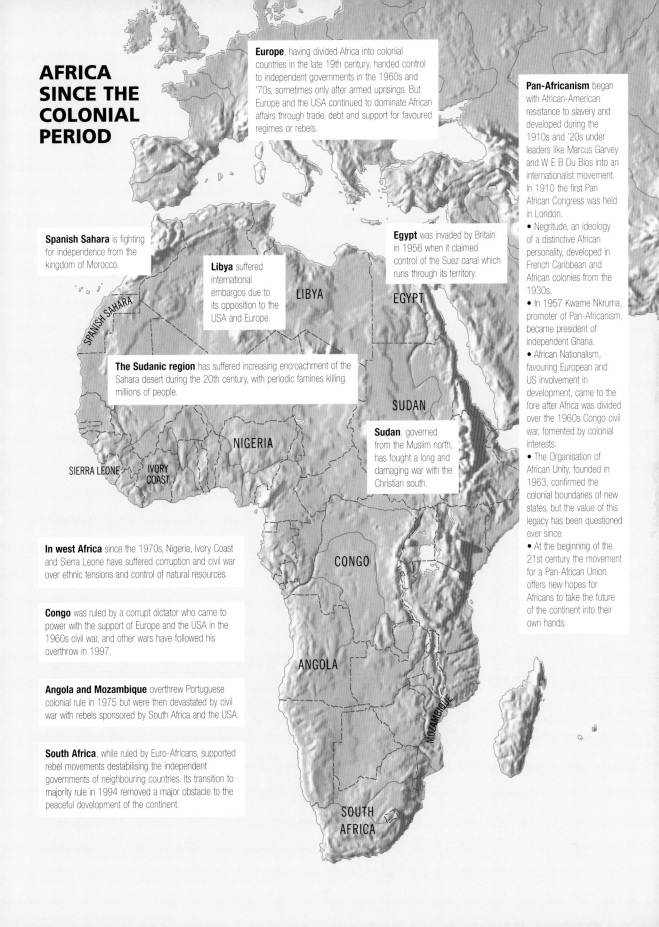

AFRICA SINCE THE COLONIAL PERIOD

Europe, having divided Africa into colonial countries in the late 19th century, handed control to independent governments in the 1960s and '70s, sometimes only after armed uprisings. But Europe and the USA continued to dominate African affairs through trade, debt and support for favoured regimes or rebels.

Pan-Africanism began with African-American resistance to slavery and developed during the 1910s and '20s under leaders like Marcus Garvey and W E B Du Bios into an internationalist movement. In 1910 the first Pan African Congress was held in London.

• Negritude, an ideology of a distinctive African personality, developed in French Caribbean and African colonies from the 1930s.

• In 1957 Kwame Nkruma, promoter of Pan-Africanism, became president of independent Ghana.

• African Nationalism, favouring European and US involvement in development, came to the fore after Africa was divided over the 1960s Congo civil war, fomented by colonial interests.

• The Organisation of African Unity, founded in 1963, confirmed the colonial boundaries of new states, but the value of this legacy has been questioned ever since.

• At the beginning of the 21st century the movement for a Pan-African Union offers new hopes for Africans to take the future of the continent into their own hands.

Spanish Sahara is fighting for independence from the kingdom of Morocco.

Libya suffered international embargos due to its opposition to the USA and Europe.

Egypt was invaded by Britain in 1956 when it claimed control of the Suez canal which runs through its territory.

The Sudanic region has suffered increasing encroachment of the Sahara desert during the 20th century, with periodic famines killing millions of people.

Sudan, governed from the Muslim north, has fought a long and damaging war with the Christian south.

In west Africa since the 1970s, Nigeria, Ivory Coast and Sierra Leone have suffered corruption and civil war over ethnic tensions and control of natural resources.

Congo was ruled by a corrupt dictator who came to power with the support of Europe and the USA in the 1960s civil war, and other wars have followed his overthrow in 1997.

Angola and Mozambique overthrew Portuguese colonial rule in 1975 but were then devastated by civil war with rebels sponsored by South Africa and the USA.

South Africa, while ruled by Euro-Africans, supported rebel movements destabilising the independent governments of neighbouring countries. Its transition to majority rule in 1994 removed a major obstacle to the peaceful development of the continent.

SPANISH SAHARA

LIBYA

EGYPT

SUDAN

NIGERIA

SIERRA LEONE

IVORY COAST

CONGO

ANGOLA

MOZAMBIQUE

SOUTH AFRICA

7

AFRICA'S DIASPORA

Since the colonial period, people of African origins have claimed the rights of citizens in the states of Europe, the Americas and beyond. In general, White Africans have found this easier than Asian or Mediterranean Africans, while Black Africans still suffer from the political and economic legacy of their ancestor's enslavement, and the cultural legacy of racism inherited by their White neighbours.

African origins mean different things in different situations. People may identify themselves with the continent their ancestors left many generations ago, with the country where they still have family, with the home their ancestors left to go to Africa, or with the country where they now live. Most share several such identities at once, representing Africa in the wider world and challenging the continuing inequities of its relationship with Europe and the Americas.

Celebrating Africa

The African and Afro-Caribbean communities of Britain contribute to the cultural diversity of our major cities. Black History Month, an educational initiative to raise the profile of African history each October, has been celebrated in the British Museum with programmes of music and dance. Siyaya, a Zimbabwe and South African group, performed to an enthusiastic audience in the Museum's Great Court in 2003.

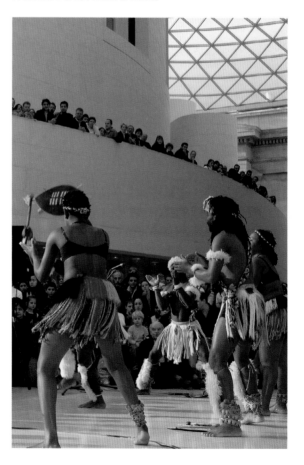

Rastafarians

Rastas identify with Africa but come from all over the world and from all backgrounds. Tim Jacques works for the British Museum in its New Media unit.

Rastas believe in the divinity of H.I.M Emperor Haile Selassie I of Ethiopia. For them, his coronation in 1930 fulfilled ancient Biblical prophecy. They were inspired by the Jamaican philosopher and prophet Marcus Garvey, who called for Jamaicans to 'look to Africa for the crowning of a Black king'.

African-American culture in museums

Few museums in Britain have much to show on African culture or history from
the Americas. But the Horniman Museum in south London includes this
reconstruction of an altar for the vodoun religion of Haita in its 'African Worlds'
gallery. Such altars are described as 'the place where the living and the dead,
the human and the divine, meet and communicate', in this religion deriving
from the Fon and Ewe peoples of west Africa. Instead of the carved figures on
west Africa altars, they use plastic dolls for human images, as well as
including Christian deities and symbols of death.

Discovering African art

Since the 19th century, Europeans have applied their own notions of 'art' to more and more products from other cultural traditions, which they first regarded as no more than 'curios'. It was artists of the 'primitivist' movement who drew the attention of art connoisseurs to sculpture from certain parts of Africa. In France in the 1900s, Picasso, Matisse and others began to use this sculpture as inspiration for their fantasies of primal emotion and magical force, reflecting the popular racism of the time, as they rebelled against the constraints of their own artistic traditions. In Britain in the 1920s, Henry Moore took a similar interest in the African collections of the British Museum, including the Luba stool shown on page 45, from which this sketch derives. He commented on its 'vitality of expression' and on the 'impression of stoicism and endurance' given by its face. But this is a Western artist's view, and we don't know if the carver intended it.

The African art diaspora

The success of the primitivists in promoting 'modernism' in European art encouraged appreciation of African sculpture as 'primitive art' and increased its commercial value. During the 20th century a profitable market for 'African art' developed in Europe and North America, and Africans have responded to it in various ways. Some buy, steal, smuggle and deal in objects which their owners and countries of origin value as heirlooms or antiquities, in an illegal trade worth hundreds of millions of pounds per year which also often involves arms and drugs. Being made and used for local purposes, such objects can be sold for exorbitant prices in the most prestigious auction houses and exhibited in famous museums and galleries as 'traditional' and 'authentic'.

Other Africans make careful reproductions of old styles, sometimes fooling collectors of 'authentic art', or cruder imitations for tourists and souvenir hunters. Some develop new styles to meet the Western demand for exaggerated non-naturalistic African art, or the kind of 'modern art' originally developed by the European primitivists under African inspiration. This work is less prestigious and valuable because it is not deemed 'traditional' or 'authentic' for African sculptors to work for the international art market, despite the fact that this is what European artists do.

Even so, there is a lively trade in these less prestigious African artefacts. This display of masks is from Afribilia, 'Dealers in African art and historical items – one minute's walk from the British Museum'. The shop sells all kinds of things from coins, military badges and postcards to textiles and 'Tribal art, masks and carved figures' which may or may not be 'traditional' or 'authentic', depending on your point of view.

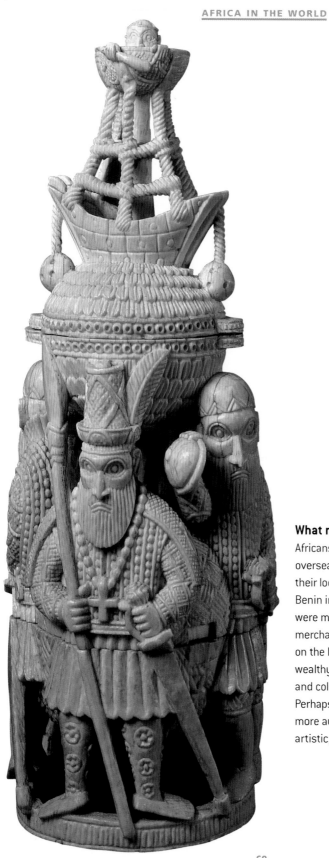

What makes African art 'authentic'?

Africans have been making artistic objects for overseas export markets for centuries, adapting their local styles to foreign tastes. In 16th century Benin in Nigeria, ivory carvings like this salt cellar were made for sale to the Portuguese, whose merchants are depicted on the base, and their ship on the lid. Such objects, originally tableware for wealthy Europeans, are now prized by museums and collectors as immensely valuable works of art. Perhaps today's commercial sculpture will become more authentic, more valuable, and even more artistic, with the passage of a few hundred years.

Contemporary African art

As Western art critics began to question the racist assumptions underlying the notion of 'primitive art' in the late 20th century, they started to treat African sculptors as 'artists'. How much the Africans who provide the market with 'primitive' or 'tribal' art have in common with Europeans who sell their own work as 'fine art' for the galleries of Europe and North America is another question. But there are also Africans who work as artists for this 'fine' or 'contemporary' art market.

This welded steel sculpture was made by Sokari Douglas-Camp, a Nigerian who has made her name as an artist while working in London. Like European artists, she draws upon the imagery of her own culture, in this case on the 'ship-on-head' masquerade of the Kalabari people (as shown in an older form on the ancestral screen on p40).

African contemporary art differs from such local sources of inspiration in sharing the Western fashion for self-conscious introspection, displaying the artist's very personal reactions to their experience of the world. This often requires them to explain the symbolism of their work, which may have the effect of confusing, irritating or offending more conventional audiences. African masqueraders work with symbolic forms well understood and approved by their local audience, which is exactly what contemporary artists, African and European, try to challenge in their work. Furthermore, as a woman Douglas-Camp is excluded from participating in the Kalabari masquerades she portrays, and would have found it hard to pursue her art in Nigeria.

African history in Western museums

The stories told by Western museum displays are increasingly challenged by African voices. One of the questions they ask is why the museums should continue to possess many of the African objects in their collections. This raises further questions . . .

How did Western museums acquire their African objects?

Most African objects came to the British Museum through the colonial relationships which brought Africa under European control from the later 19th century. They include items which were:

● Looted, given as tribute, or taken in battle during colonial conquest.
● Presented as diplomatic gifts to colonial officials or VIPs.
● Taken by Christian missionaries as trophies of conversion from local religions which no longer needed them.
● Given or sold to European visitors and residents as mementoes of the place or people.
● Purchased by researchers to document local culture or by collectors or dealers as art objects.
● Stolen and sold on the art market.
● Given to Europeans in order to preserve them.

. . . and should they keep them?

Arguments for and against returning museum collections to their place of origin include:

● Stolen property should be returned and historical injustices made good.
● People are not responsible for the deeds of former generations.
● People should not continue to benefit from the misdeeds of their ancestors.
● People should be able to learn about their own culture and history from their own artefacts.
● People should be able to learn about the culture and history of other countries from *their* artefacts.
● The culture of colonised peoples is also part of the heritage of colonising countries and their multi-ethnic populations.

Some complications to the debate . . .

● If stolen artefacts are to be returned, should they go to the national or local authorities or museums of countries which were created by the colonial powers, or to the heirs of those from whom they were stolen, if there are any and they can be found?
● Should we consider whether or not these state authorities or heirs are likely to preserve the artefacts from decay, theft or sale abroad?
● Even apart from theft, is there any fair way for rich countries to obtain cultural property from underdeveloped parts of the world where people are desperate to sell whatever they can to save themselves from poverty?
● Compared to other past and present injustices in Africa's relationship with Europe and America, how important is the theft of artefacts, and how much can be achieved by returning them? What about the stolen people whose slave labour enriched European countries, the stolen resources extorted under colonialism, and the debt repayments demanded from poor African countries by Western banks?

The British Museum is one of many places where British people
of any background can go to learn about African culture. This
music workshop was part of Black History Month 2000.

KEY TO ILLUSTRATIONS

Unless otherwise stated, objects illustrated are in the British Museum and images are © The Trustees of the the British Museum. The list gives the name of the department and registration number.